A CAPITAL COLLECTION

COLLECTION

VIRGINIA'S ARTISTIC INHERITANCE

A CAPITAL COLLECTION

VIRGINIA'S ARTISTIC INHERITANCE

BY BARBARA C. BATSON AND TRACY L. KAMERER

THE LIBRARY OF VIRGINIA
RICHMOND ▪ 2005

PUBLISHED BY AUTHORITY OF THE LIBRARY BOARD

LIBRARY OF CONGRESS CATALOGING-IN-PUBLICATION DATA

Batson, Barbara C.
 A capital collection : Virginia's artistic inheritance / by Barbara C. Batson and Tracy L. Kamerer.— 1st ed.
 p. cm.
 Includes bibliographical references and index.
 ISBN 0-88490-204-8 (casebound: alk. paper) 1. Virginia—Biography—Portraits—Exhibitions. 2. Politicians—Virginia—Portraits—Exhibitions. 3. Statesmen—United States—Portraits—Exhibitions. 4. Governors—Virginia—Portraits—Exhibitions. 5. Virginia—In art—Exhibitions. 6. Art, American—Virginia—Richmond—Exhibitions. 7. Art—Virginia—Richmond—Exhibitions. 8. Library of Virginia—Art collections—Exhibitions. 9. Virginia State Capitol (Richmond, Va.)—Art collections—Exhibitions. 10. Virginia Executive Mansion (Richmond, Va.)—Art collections—Exhibitions. I. Kamerer, Tracy L. II. Title.
F223.B37 2005
975.5'451—dc22 2005009780

708 BAT

LIBRARY OF VIRGINIA, RICHMOND, VIRGINIA.
© 2005 BY THE LIBRARY OF VIRGINIA.
ALL RIGHTS RESERVED.
PRINTED IN THE UNITED STATES OF AMERICA.

ISBN-13: 978-0-88490-204-8
ISBN-10: 0-88490-204-8 CASEBOUND

THIS BOOK IS PRINTED ON ACID-FREE PAPER MEETING REQUIREMENTS OF THE
AMERICAN STANDARD FOR PERMANENCE OF PAPER FOR PRINTED LIBRARY MATERIALS.

CONTENTS

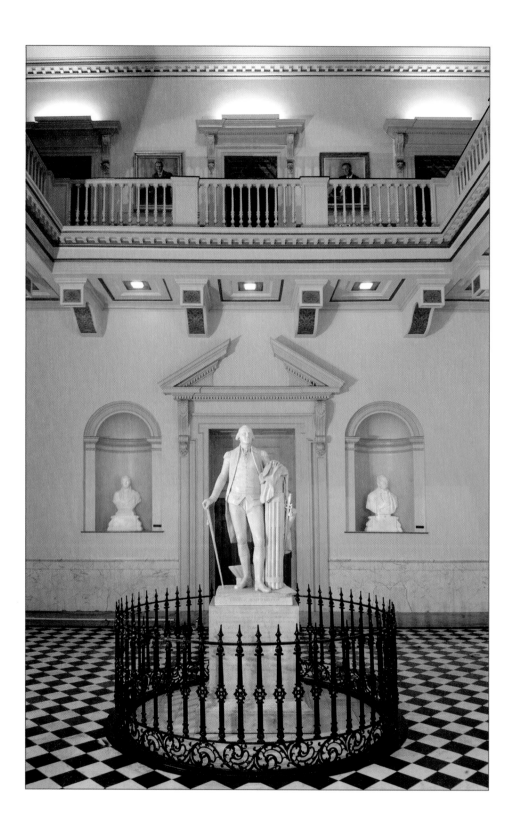

FOREWORD

When Thomas Jefferson designed the Virginia State Capitol in 1785, he envisioned a heroic statue of George Washington beneath its Rotunda, thus establishing the Capitol, its adjacent square, and surrounding government buildings as home to a remarkable public collection of art.

In 1796, Jean-Antoine Houdon's magnificent life-size marble statue of George Washington (*left*) was at last placed in its position of honor. Since then, Virginians have with care and a discerning eye continued to add significant sculpture and paintings throughout the Capitol's hallways and chambers. The immense and spectacular *Storming of a British Redoubt by American Troops at Yorktown*, depicting the 1781 capture of one of the battlefield's key fortifications, the marble statue of Henry Clay by Joel Tanner Hart, Houdon's striking marble likeness of the marquis de Lafayette, the bronze bust of Patrick Henry by Frederick William Sievers, and the life portrait of John Marshall by Henry Inman are but a few of the most distinguished examples. To these exceptional creations must be added the many fine works displayed on Capitol Square—such as Thomas Crawford's monumental equestrian bronze of George Washington—as well as others often exhibited in the Executive Mansion—the triple portrait of the famed early-nineteenth-century American Indian leaders *The Prophet Wabokieshiek, Black Hawk, and Nasheaskuk* by James Westhall Ford, for example, or the landscape of the Jackson River in western Virginia by Russell Smith.

All these and more are worthy of our attention, for together they represent an extraordinary perspective on many of the individuals, subjects, and places that have most captured our collective memory. These splendid works of art speak to the history and culture of Virginia. We invite you to enjoy—to marvel in—Virginia's artistic inheritance.

SUSAN CLARKE SCHAAR
Clerk of the Senate of Virginia

BRUCE F. JAMERSON
Clerk of the House of Delegates and
Keeper of the Rolls of the Commonwealth

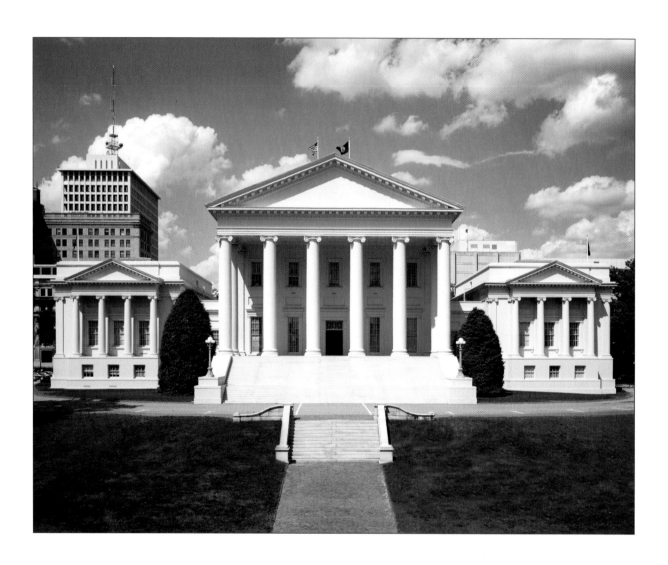

INTRODUCTION

Virginia's state art collection is a significant body of work and also a key component of its physical setting, the eighteenth-century Capitol and the surrounding public park known as Capitol Square. The character of the collection reflects and enhances the grand, yet democratic nature of the Capitol, which Thomas Jefferson designed to serve as a temple to democracy. Today it seems obvious that a world-class building, intended as a model for its citizens, would have an art collection of equal stature. Jefferson hoped that the Capitol, inspired by a Roman temple, would in turn inspire the citizens of his young country. Embracing a tenet of the Age of Enlightenment, he and his contemporaries thought that great examples of architecture and art can serve as role models for living a life of merit and value.

Jefferson believed that architecture and art, together with history and literature, were tools with which to build the new republic. He was the only founding father who took an enthusiastic interest in art and its public uses, and his taste is largely responsible for the high and eclectic quality of Virginia's collection. Jefferson personally participated in the acquisition of the first, and perhaps the best, works in the collection. He believed strongly in the instructive character of art, that it could provide relief from the mundane aspects of daily life, serve as a public record of historic events, and provide examples for posterity.[1]

The initial impulse under which the Virginia General Assembly began the collection was similarly didactic, fully in accord with the spirit of ancient times, when it had been widely believed that works of art and monuments could serve as *exempla virtutis* (models of virtue) for the public. This sentiment was surely a major motivation of Virginia's legislators, who believed that portraits of great people could fulfill the same purpose. In addition to the preservation of likenesses, these works of art serve as reminders of the deeds of eminent people and of the debts owed to them. The first works that the state acquired were a full-length statue of George Washington and a bust of the marquis de Lafayette, both by French artist Jean-Antoine Houdon. The assembly commissioned them as gestures of thanks and remembrance for Washington's and Lafayette's

services to the commonwealth and the country during the American Revolution. By the time the statue of Washington was commissioned, Jefferson had already begun designing the new Capitol building, creating the central Rotunda with the statue in mind.

Virginia led the way in commemorating the achievements and character of Washington, the classic *exemplum virtutis*, venerated in his time and still revered today. A commentator early in the twentieth century, proposing to make copies of Houdon's Washington, reflected the forefathers' intentions "to transmit to posterity an exact and faithful likeness of the face and form of *Washington*, to the end that all the people for all time might enjoy the priceless privilege of knowing the actual personal appearance of the Father of our Country, so that by perpetually fostering a feeling of personal acquaintance with George Washington, he might forever continue to be First in the Hearts of his Countrymen."[2]

During the first half of the nineteenth century, the state collected portraits of other prominent Virginians, including Chief Justice John Marshall and Presidents Thomas Jefferson, James Monroe, and John Tyler. The state collection expanded greatly after the General Assembly in 1873 authorized the acquisition of works of art "relating to the history of Virginia" by the State Library. The Library embarked on a mission to collect portraits of each governor of the commonwealth and of other prominent figures. The collection grew by both purchase and gift. The assembly and the State Library also sought to honor and record important persons from the Civil War period. Early in the 1930s, many of the likenesses were placed in the chamber that the House of Delegates had occupied until 1904, when the Capitol was enlarged. The old chamber was renovated and dedicated in 1932 to perpetuate the memory of distinguished antebellum Virginians. Shortly before, state officials had finalized plans to make the adjacent Capitol Rotunda, where Houdon's statue of Washington had stood since 1796, a "hall of presidents, which no other State of the Union can equal or surpass." The planners believed that the hall would "bring visitors from all parts of the United States

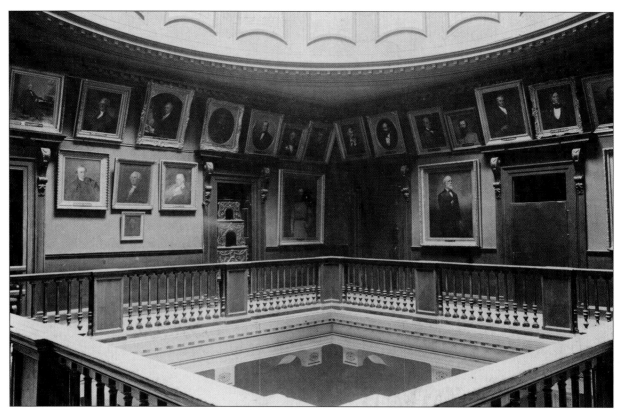

THE THIRD FLOOR GALLERY UNDER THE DOME, SHOWN HERE BEFORE 1893, WAS THE MAIN DISPLAY AREA FOR ART IN THE CAPITOL BY THE END OF THE NINETEENTH CENTURY. TODAY THE AREA SERVES AS A PORTRAIT GALLERY FOR RECENT GOVERNORS.

into a realization of what Virginia has contributed to the nation," and the Rotunda soon featured busts of all the other Virginia-born presidents of the United States as well as Houdon's bust of Lafayette. The assembly also restored the old Senate chamber in 1954, and the room now displays large-scale paintings commemorating the settlement of Jamestown in 1607 and the siege of Yorktown in 1781.[3]

The collection continued to grow in size and variety during the twentieth century, and a pattern of acquisition developed. Possibly inspired by the Library's success in collecting portraits of governors, the General Assembly and the Supreme Court of Virginia began acquiring portraits of prominent legislators and judicial officials. Portraits of governors, lieutenant governors, Speakers of the House of Delegates, and members of the Supreme Court are regularly added to the collection.

Before the age of photography, a painted, sculpted, or sketched portrait was the only way to record a likeness.

When first painted, some of the portraits in the state collection may have been the only known record of a public figure's actual appearance, but even after easy multiplication of images became possible, artistic portraits continued to serve the original purpose of exhibiting role models for future generations and of honoring the subjects.

The manner in which Virginia's leaders have been represented has reflected changing attitudes over time. Houdon's sober, republican *George Washington* was the image of a revered general presented as a civilian farmer, dressed in his military uniform, combining his civic and military roles in the founding of the nation. Part of the great popularity of the statue was that it presents Washington as a man of the eighteenth century, not as a mythic figure or god from antiquity. Washington as the American Cincinnatus, who gave up great power to return to his farm, appealed to a citizenry that had just broken with a royalist system.

During the nineteenth century, Americans chose to honor Washington and other significant Virginians in different ways. Commissioners soliciting designs for an outdoor monument to Washington for Capitol Square in the 1840s envisioned something monumental and grand. The commissioners' selection of Thomas Crawford's bronze equestrian statue as the winning design reflected both a willingness to embrace a more martial Washington and a growing acceptance of European artistic conventions. The commissioners and the artist also decided that the memorial should pay tribute to other great Virginians who took part in the Revolutionary cause, emphasizing state as well as national figures and ideals. The heroic equestrian statue and its group of significant Virginians represented the same impulse that had always inspired such works of art, a belief that great men and their ideals cast in bronze, larger than life, would have an impact on future generations.

European tradition held a strong influence on American art during the nineteenth century. The United States was becoming more assured of its place in the world, and Americans sought out known artistic idioms without fear of associations with European political systems. Wealthy Americans took the requisite Grand Tour, gaining firsthand knowledge of European tastes, and ambitious American artists received training or lived abroad. Many of the works in the state collection were created by such artists, thus the classic appearance of George P. A. Healy's 1846 portrait of Senator William Segar Archer and of Harriet Goodhue Hosmer's ca. 1861 *Cupid on Dolphin*. Works of art produced later in the nineteenth century and thereafter show the effects of modernism on American art and differ from traditional models.

The history of Virginia's art collection and its display is a microcosm of changing styles, taste, and public patronage over two centuries, and these works can still teach us much about the past and about ourselves. Today the collection consists of approximately four hundred paintings and works of sculpture owned by the Commonwealth. Many are on display in state buildings in the Capitol Square area, but some are rarely seen due to a lack of display space or their placement in nonpublic areas in the square's buildings. Nearly every wall space in the Capitol has been covered with paintings for most of the last century, and the Supreme Court's chamber is filled with portraits.

The Commonwealth and the Library currently are working hard to ensure that the state art collection will keep telling its stories. On 12 January 1998, Governor George F. Allen issued an executive order conferring on the Library of Virginia responsibility for "the care and oversight" of works of art in the Capitol Square area. The Library had informally assisted with and cared for the collection in the past, but the

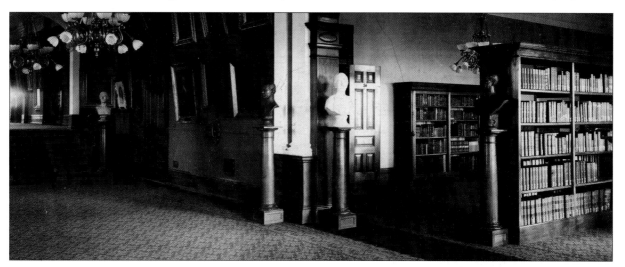

EARLY IN THE TWENTIETH CENTURY, MANY WORKS OF ART IN THE STATE COLLECTION WERE DISPLAYED IN THE STATE LIBRARY, NOW KNOWN AS THE FINANCE BUILDING, ON THE EASTERN EDGE OF CAPITOL SQUARE. THIS IMAGE SHOWS THE READING ROOM AND CENTRAL HALL, CA. 1910.

formalization of the arrangement allowed the Library to hire the first curator of the collection and allocate a budget solely for conservation. Under the guidance of the Library of Virginia, the collection has undergone evaluation, conservation, and research. In 1997 the agency moved to a new, spacious building and within a few years constructed a museum-quality storage facility for works of art.[4]

The major buildings in Capitol Square are also receiving much-needed improvements that will enhance the display and care of the state's art. The Executive Mansion underwent extensive renovation in 1999, and between 2004 and 2007 the Capitol will be rehabilitated and expanded, allowing for proper exhibition of the most significant works of art. These improvements will ensure that the collection born with the Capitol will continue to serve Virginia's citizens.

Visitors and Virginians alike can find much to learn from and to appreciate in the Capitol Square and its collections. Portraits in the collection honor ancestors but also raise questions about the nature of leadership for the future. Sculpture, paintings, and architecture provide a useful catalog of American artistic tastes, achievements, and influences. Landscape scenes show that Virginians appreciate beauty and also have a strong sense of place. The collection contains both valuable artifacts and aesthetically pleasing works of art, but much of the value of the collection lies in what it says about the history and culture of the Old Dominion. It celebrates who Virginians were, are, and hope to be, by providing examples of greatness, beauty, and merit. The collection itself is an *exemplum virtutis*, a testament to great Virginians and Virginia's great places.

<div align="center">

TRACY L. KAMERER
Curator of the State Art Collection
The Library of Virginia

</div>

NOTES

1. For more information about Jefferson's views on the arts, see William Howard Adams, ed., *The Eye of Thomas Jefferson* (Washington, D.C.: The National Gallery of Art, 1976), especially xxxiii–xli; and Harold E. Dickson, "Jefferson as Art Collector," *Jefferson and the Arts: An Extended View* (Washington, D.C.: The National Gallery of Art, 1976), 101–132.

2. *Why the Houdon Statue of Washington Should Be Copied: Information Concerning Senate Bill No. 113* (Providence, R.I.: Gorham Manufacturing Company, 1914), 3.

3. Act of 4 February 1873, *Acts and Joint Resolutions Passed by the General Assembly . . . 1872–'73* (Richmond: R. F. Walker, Superintendent of Public Printing, 1873), 36 (1st quotation); Act of 22 March 1932, *Acts of the General Assembly . . . Session Which Commenced . . . January 13, 1932* (Richmond: Division of Purchase and Printing, 1932), 343; *Journal of the House of Delegates . . . January 8, 1930* (Richmond: Division of Purchase and Printing, 1930), 251 (2d and 3d quotations); *Journal of the Senate of Virginia . . . Beginning . . . January 13, 1954* (Richmond: Division of Purchase and Printing, 1954), 1074.

4. Virginia, Governor (1994–1998: Allen), Executive Memorandum 1-98, *Care and Oversight of the Art Collections of the Commonwealth Exhibited in the Capitol Square Area*, 12 January 1998 (Richmond: Commonwealth of Virginia, Governor's Office, 1998). With the help of the General Assembly and the Department of General Services, the Library has implemented regular maintenance, inspection, and conservation campaigns for works of art inside and outside the Capitol.

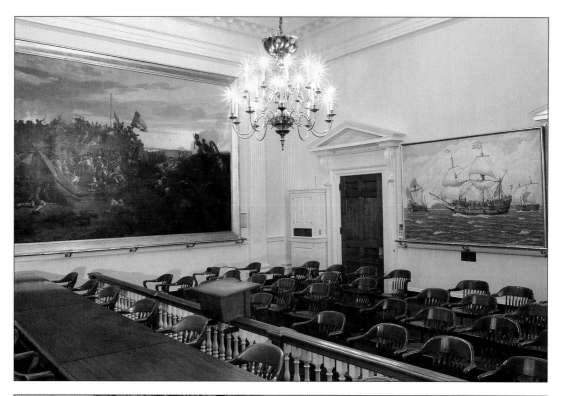

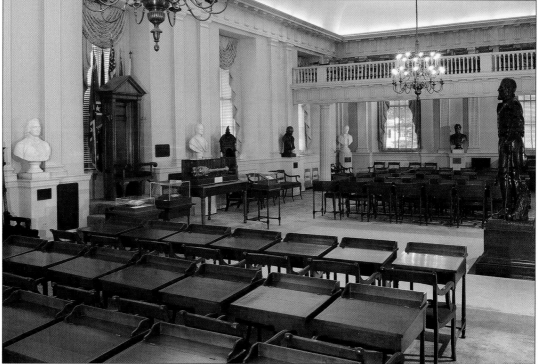

OLD SENATE CHAMBER (*top*); OLD HALL OF THE HOUSE OF DELEGATES (*bottom*)

ACKNOWLEDGMENTS

In 2005 the Virginia State Capitol closed for much-needed renovation and rehabilitation to meet the continuing requirements of the state's elected officers and the General Assembly of the Commonwealth. Preparing for the closure and subsequent removal of works of art from the building encouraged the Library of Virginia to plan an exhibition highlighting approximately fifty paintings and sculptures from the state art collection, consisting of works residing in state buildings around Capitol Square, including the State Capitol, the Executive Mansion, the Supreme Court of Virginia, and the Library itself. As we pondered the pros and cons of producing a catalog of the exhibition, we realized that a greater service would be the publication of a book that highlighted some of the best pieces of art in the state collection, including some of the statues in Capitol Square and two outstanding works—Jean-Antoine Houdon's *George Washington* and Eugène Louis Lami's *Storming of a British Redoubt by American Troops at Yorktown*—that, because of their size, could not be placed on view at the Library. The resulting volume of photographs and the accompanying essays will provide those interested in Virginia's artistic heritage with a well-researched and -illustrated companion volume to the exhibition. A database of the state art collection will soon be available through the Library's Web site as well.

Production of this volume resulted from the support, cooperation, and encouragement of state officials who manage the buildings around Capitol Square. First and foremost, we thank Susan Clarke Schaar, Clerk of the Senate, and Bruce F. Jamerson, Clerk of the House of Delegates. Their ongoing commitment to the collection and their support of the work of the Library of Virginia has been invaluable. We also thank James E. Wootton, Executive Director of the Capitol Square Preservation Council, and Mark Greenough, Supervisor and Historian, State Capitol Guided Tours, who each continually provide useful information, insight, and constructive criticism.

Planning for the closure of the Capitol made it imperative that all art be photographed and evaluated. The current volume uses the photography created by Pierre Courtois and Susanna Reynolds, staff photographers at the Library of Virginia, to whom we express our appreciation.

Our colleagues in the Publications and Educational Services Branch, Gregg D. Kimball, Brent Tarter, and Emily J. Salmon, worked their editorial magic and shepherded the volume through design and production, G. W. Poindexter kindly read the manuscript for us, and Ann E. Henderson assisted with production. David Vess and Steve Stuart combed through the records to determine provenance and to provide basic information on the artists, and the Special Collections staff generously contributed their research skills.

Amy C. Winegardner, the Library's graphic designer, never ceases to amaze and astound with her ability to design with an eye toward the aesthetic and a mind toward the reader. The look of the current volume is a credit to Amy's sense of elegance.

We turned to other scholars and researchers who answered questions about specific works or artists, and they are acknowledged in the individual entries. But to one and all, we give our thanks for their willingness to share information and to point us to other avenues of research and for their patience in helping to make the current volume a reality.

A CAPITAL COLLECTION

COLLECTION

VIRGINIA'S ARTISTIC INHERITANCE

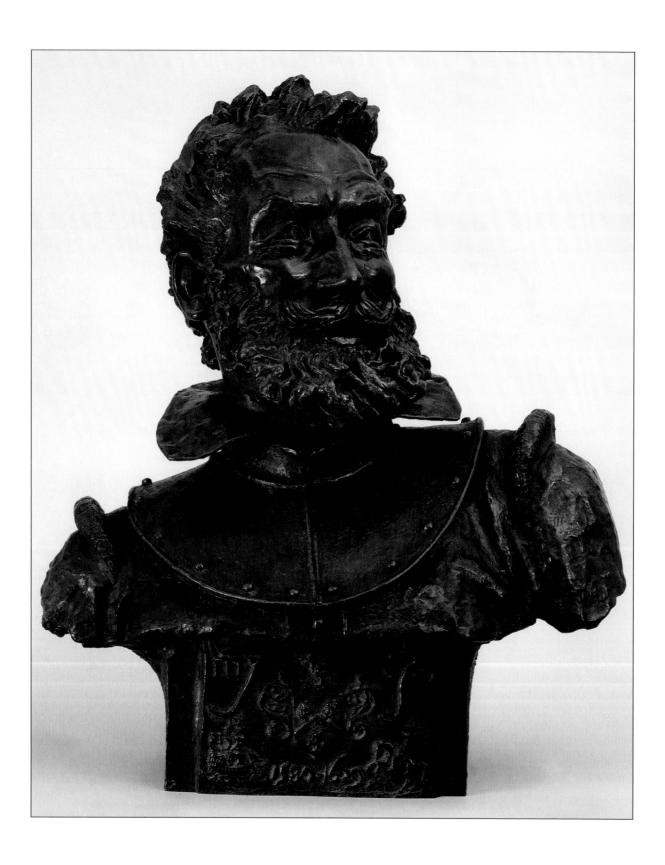

ROBERT S. S. BADEN-POWELL, FIRST BARON BADEN-POWELL OF GILWELL (1857–1941) JOHN SMITH (1580–1631)

Ca. 1905
Bronze
Height 23 inches
Collection of the Library of Virginia, gift of Charles Mayer

Best known as the founder of the Boy Scout movement, Robert Stephenson Smyth Baden-Powell was also an accomplished artist. Born in London, England, on 22 February 1857, he was the son of Baden Powell, a theologian and professor of geometry at Oxford, and Henrietta Grace Smyth Powell, who about 1870 adopted the hyphenated surname for herself and her children. Baden-Powell entered the army as a junior officer and in 1876 was posted to India, where he developed his skills in reconnaissance and scouting. In the Boer War of 1899–1900, he achieved renown for his leadership during the siege of Mafeking. His ingenuity and organization enabled British troops to defend the small town against a much larger force. The siege was lifted on 17 May 1900, and Baden-Powell was promoted to major general. He retired from the army in 1910 with the rank of lieutenant general.[1]

A prolific writer on military subjects, Baden-Powell published *Scouting for Boys* in 1908 as an outgrowth of his experiences training cadets in military scouting. The Boy Scout movement stressed outdoor activities and organized individual troops under a leader. Baden-Powell founded the Girl Guides, initially headed by his sister, Agnes Baden-Powell, in 1910. After his retirement from the army, Baden-Powell focused his attention on the Boy Scouts and Girl Guides, which spread rapidly throughout the British Empire and other countries, including the United States. He became baron Baden-Powell of Gilwell in 1929. Robert Baden-Powell died in Nyeri, Kenya, on 8 January 1941.[2]

Throughout his life, Baden-Powell turned to art as recreation. His watercolors of Mafeking were exhibited and published in 1907. Describing him in an article in the January 1906 *Jamestown Bulletin*, Gilberta S. Whittle wrote that Baden-Powell "could sing a song, tell a good story and take part in a comedy either as actor or manager. He could also write, draw a clever caricature, and paint from nature and model in clay." About 1905 Baden-Powell executed a bust of Captain John Smith, the Virginia explorer whom he had long admired and from whom his mother claimed descent. Baden-Powell told Whittle that because Smith "was a soldier, a sailor and an administrator," it had been "difficult to give hints of all three in one face." Modeled in clay and cast in bronze, the bust captures Smith as a dynamic personality and strong leader.[3]

The artist and his subject had much in common: both were military men, authors, and key figures in British colonial matters. Smith was born in Lincolnshire, England, sometime in 1580 and was apprenticed to a merchant before entering the Austrian army during that country's war against Turkey. Captured and enslaved, Smith escaped and returned to England in the winter of 1604–1605. He was one of the colonists who settled Jamestown in Virginia in the spring of 1607. A member of the governing Council, he was its president from September 1608 to September 1609, effectively governor of the colony. In addition to helping the colony survive its first two years, Smith led exploring expeditions and later wrote extensively about the settlement, the Virginia Indians, and colonization. His principal books, *A True Relation of Such Occurrences and Accidents of Noate as Hath Hapned In Virginia* (1608), *A Map of Virginia* (1612), *A Description of New England* (1616), and several editions of the *Generall Historie of Virginia, New-England, and the Summer Isles* (first published in 1624), made him the most famous authority on the settlement of Virginia. Captain John Smith, as he is almost always known, died in London on 21 June 1631.[4]

Charles Mayer, of New York and the son of a Virginian, presented the bronze bust to the Commonwealth in 1906. In his letter to the General Assembly, Governor Claude A. Swanson wrote that "the generous and patriotic motive which prompted this act, the profound esteem and affectionate appreciation which the people of Virginia entertain for the distinguished services rendered by

Captain John Smith to Virginia, must necessarily make this gift one to be highly prized and treasured by the people of this Commonwealth."[5]

<div align="center">BCB</div>

<div align="center">⬿</div>

NOTES

1. Allen Warren, "Powell, Robert Stephenson Smyth Baden-, first Baron Baden-Powell," *Oxford Dictionary of National Biography* (New York and Oxford, Eng.: Oxford University Press, 2004), 45:112–115. See also Tim Jeal, *Baden-Powell*, 2d ed. (New Haven, Conn.: Yale University Press, 2001).

2. Warren, "Powell, Robert Stephenson Smyth Baden-," 115–117.

3. Gilberta S. Whittle, "Baden-Powell a Descendant of Captain John Smith," *Jamestown Bulletin* 2, no. 1 (January 1906): 2–3.

4. Karen Ordahl Kupperman, "Smith, John," *American National Biography* (New York and Oxford, Eng.: Oxford University Press, 1999), 20:222–224.

5. *Journal of the House of Delegates of the State of Virginia . . . 1906* (Richmond: Davis Bottom, Superintendent of Public Printing, 1906), 710; Gregg D. Kimball and Edward D. C. Campbell Jr., "John Smith," in *The Common Wealth: Treasures from the Collections of the Library of Virginia*, ed. Sandra Gioia Treadway and Edward D. C. Campbell Jr. (Richmond: The Library of Virginia, 1997), 263.

REFERENCES

Jeal, Tim. *Baden-Powell*. 2d ed. New Haven, Conn.: Yale University Press, 2001.

Kimball, Gregg, and Edward D. C. Campbell Jr. "John Smith." In *The Common Wealth: Treasures from the Collections of the Library of Virginia*. Edited by Sandra Gioia Treadway and Edward D. C. Campbell Jr., 263. Richmond: The Library of Virginia, 1997.

Kupperman, Karen Ordahl. "Smith, John." *American National Biography*, 20:222–224. New York and Oxford, Eng.: Oxford University Press, 1999.

Warren, Allen. "Powell, Robert Stephenson Smyth Baden-, first Baron Baden-Powell." *Oxford Dictionary of National Biography*, 45:112–118. New York and Oxford, Eng.: Oxford University Press, 2004.

Whittle, Gilberta W. "Baden-Powell a Descendant of Captain John Smith." *Jamestown Bulletin* 2, no. 1 (January 1906): 2–3.

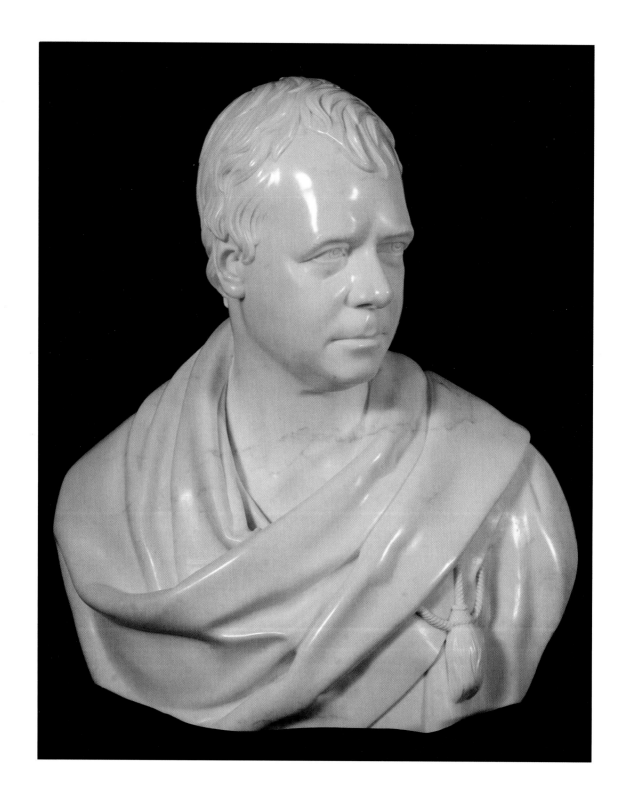

SIR FRANCIS LEGGATT CHANTREY (1781–1841)
SIR WALTER SCOTT (1771–1832)

Undated copy after 1820–1821 original
Marble
Height 25¾ inches
Collection of the Library of Virginia, gift of Arthur
Morson Seddon and Josephine Venable Seddon

One of the most important British sculptors of all time, Sir Francis Chantrey was trained as a craftsman. The son of a tenant farmer and carpenter, he was born on 7 April 1781 at Jordanthorpe in the parish of Norton, Derbyshire, England. Apprenticed to a carver and gilder in 1797, he probably learned to work with stone from a mason. Chantrey also took drawing lessons from the engraver John Raphael Smith. In 1802 he began a career painting portraits and moved to London, where he received his first commission for a bust in 1805. He studied at the Royal Academy of Arts and had his first major success there in 1811. Chantrey's fame and wealth grew rapidly. He executed a bust of George III, who sat for him in 1809, and he was elected to the Royal Academy and to the Royal Society in 1818. Chantrey sculpted many of the leading British figures of his day and was knighted in 1835. Sir Francis Leggatt Chantrey died in London on 6 December 1841 and bequeathed more than £100,000 to the Royal Academy to create the Chantrey Bequest for the acquisition of works of art.[1]

Throughout his career, Chantrey's focus was on portraiture. The marble bust of Sir Walter Scott (1771–1832), one of his most popular works, was unusual in that the artist asked the writer to sit for him. "My admiration of Scott as a poet and a man," Chantrey wrote, "induced me, in the year 1820, to ask him to sit to me for his Bust—the only time I ever recollect having asked a similar favour from any one." Born in Edinburgh, Scotland, on 15 August 1771, Scott was educated at the University of Edinburgh. He studied law but relished poetry, literature, and the lore of Scotland. His poetry, romances, and historical novels were widely read on both sides of the Atlantic Ocean and were particularly popular in the American South. Created a baronet at the end of 1818, Sir Walter Scott died at Abbotsford, Scotland, on 26 September 1832.[2]

Scott sat for Chantrey, who held the writer in high regard, probably seven times in March and April 1820, and the men became good friends. The artist's secretary stated that Chantrey intended "to seize a poetical phasis of Scott's countenance; and he proceeded to model the head as looking upwards, gravely and solemnly." After chatting with Scott, however, the artist changed his mind, cut the head off the model, repositioned it, and began again, hoping to capture the writer's "conversational look," to "take him when about to break into some sly funny old story." Chantrey achieved a casual air by means of a relaxed countenance and the gentle turn of Scott's head. The resulting attitude is informal and immediate, as if the writer is in thought, preparing to speak. This informality is unusual in Chantrey's oeuvre.[3]

The Scott bust has a touch of classical antiquity with its togalike wrap, but it also has a very lifelike, immediate quality. This combination of respect for tradition and strong naturalism is characteristic of Chantrey's style. In 1821 Chantrey exhibited the bust alongside his bust of William Wordsworth at the Royal Academy. Considering Scott's bust to be his finest, Chantrey apparently kept the original in his studio after the exhibition, where he and his staff made a number of plaster and marble copies. In 1828 the sculptor offered to give the original marble bust to Scott on the condition that the writer sit again for another, so that the artist could have one for himself.[4]

In 1904 the Library of Virginia acquired a marble copy after the original marble bust, which differs in several details from the original, from Arthur Morson Seddon and Josephine Venable Seddon, of Richmond.[5]

TLK

NOTES

1. E. Beresford Chancellor, *The Lives of the British Sculptors* (London: Chapman & Hall, 1911), 260–266; Clyde Binfield, Introduction, in *Sir Francis Chantrey: Sculptor to an Age, 1781–1841*, ed. Clyde Binfield (Sheffield, Eng.: University of Sheffield, 1981), 16; Alex Potts, *Sir Francis Chantrey, 1781–1841: Sculptor of the Great* (London: National Portrait Gallery, 1980), 7.

2. Francis Russell, *Portraits of Sir Walter Scott: A Study of Romantic Portraiture* (London: Printed for the Author by White Brothers, 1987), quoting Chantrey on 32.

3. John Gibson Lockhart, *Memoirs of the Life of Sir Walter Scott, Bart.* (Edinburgh: Robert Cadell, 1837–1838), 4:362–366 (quoting Chantrey's secretary, Allan Cunningham, on 363, 365).

4. Russell, *Portraits of Sir Walter Scott*, 16, 32–35.

5. The sculptor introduced minor changes to the details of the copies. Potts, *Sir Francis Chantrey, 1781–1841*, 21; Earl Gregg Swem, "A List of the Portraits and Pieces of Statuary in the Virginia State Library, With Notes and Illustrations," *Bulletin of the Virginia State Library* 13 (1920): 24.

REFERENCES

Binfield, Clyde, ed. *Sir Francis Chantrey: Sculptor to an Age, 1781–1841*. Sheffield, Eng.: University of Sheffield, 1981.

Dunkerley, S. *Francis Chantrey, Sculptor: From Norton to Knighthood*. Sheffield: The Hallamshire Press, 1995.

Hewitt, David. "Scott, Sir Walter." *Oxford Dictionary of National Biography*, 49:490–510. New York and Oxford, Eng.: Oxford University Press, 2004.

Potts, Alex. *Sir Francis Chantrey, 1781–1841: Sculptor of the Great*. London: National Portrait Gallery, 1980.

Russell, Francis. *Portraits of Sir Walter Scott: A Study of Romantic Portraiture*. London: Printed for the Author by White Brothers, 1987.

Stevens, Timothy. "Chantrey, Sir Francis Leggatt." *Oxford Dictionary of National Biography*, 11:20–25. New York and Oxford, Eng.: Oxford University Press, 2004.

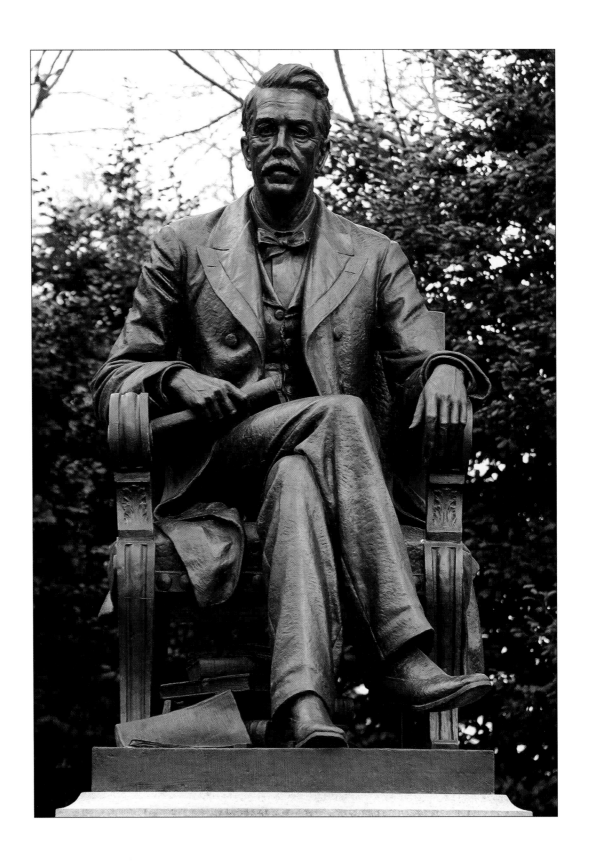

WILLIAM COUPER (1853–1942)
DR. HUNTER HOLMES McGUIRE (1835–1900)

1904
Bronze with granite pedestal
Height 14 feet
Inscriptions: on base proper right "Wm Couper / New York"; on base proper left "Gorham Mfg. Co. Founders"; on front of pedestal "To / HUNTER HOLMES McGUIRE, M.D. LL.D. / President of the American Medical / and of the American Surgical Associations; / Founder of the University College of Medicine; / Medical Director, Jackson's Corps, / Army of Northern Virginia; / an eminent civil and military surgeon, / and beloved physician; / an able teacher and vigorous writer, / a useful citizen and broad humanitarian, / gifted in mind and generous in heart, / this monument is erected by his many friends."; on back of pedestal "HUNTER HOLMES McGUIRE / Born Oct. 11, 1835. / Died Sept. 19, 1900."
Collection of the Commonwealth of Virginia, gift of the Hunter McGuire Memorial Association

William Couper, born on 20 September 1853 and the son of the founder of the Couper Marble Works in Norfolk, Virginia, developed into an accomplished and well-regarded sculptor. He studied at the Cooper Art Institute in New York from 1872 to 1874 and at the Royal Academy in Munich from 1874 to 1875. Couper then moved to Florence, Italy, where he became a pupil of Thomas Ball and in 1878 married Ball's daughter, Eliza Chickering Ball. Couper shared a studio with Preston Powers, a son of sculptor Hiram Powers, and arranged for marble and statuary to be shipped to his father's company in Norfolk. He worked and relaxed with other American artists, including Joel Tanner Hart, Frank Duveneck, and Daniel Chester French. Couper remained in Italy for twenty-two years and sent his work to the United States for sale through Tiffany and Company. In 1892 he was appointed to the sculpture advisory committee for the World's Columbian Exposition. Couper returned to the United States permanently in 1897 and settled in Montclair, New Jersey, where he built an Italian-style villa. He was a member of the National Sculpture Society and of the Architectural League and a founding member and trustee of the Montclair Art Museum. He retired from sculpture in 1913 to concentrate on painting. William Couper died in Easton, Maryland, on 22 June 1942, and his ashes were buried in Elmwood Cemetery in Norfolk, the location of his sculpture *Recording Angel*.[1]

In a career that lasted more than thirty-five years and produced more than 150 sculptures, Couper displayed in his works a mixture of romanticism and realism grounded in a thorough understanding of anatomy. His figures of angels are particularly striking. Sculptor and critic Lorado Taft wrote that Couper's angels "are not merely pretty, but they are beautiful, radiant creations, gracefully conceived, carefully drawn, and exquisitely carved." Couper received commissions for several large works, including monuments for the National Military Park in Vicksburg, a series of portrait busts of scientists for the American Museum of Natural History, and a Confederate soldier for Norfolk. He executed several sculptures of Virginians. In 1903 he completed the bronze statue of Hunter Holmes McGuire for Capitol Square in Richmond and four years later a heroic statue of Captain John Smith for the Association for the Preservation of Virginia Antiquities. A bronze copy of the Smith statue was unveiled at Jamestown in 1909.[2]

Hunter Holmes McGuire was born in Winchester, Virginia, on 11 October 1835 and studied medicine at Winchester Medical College and Jefferson Medical College, in Philadelphia, receiving his first M.D. in 1855; five years later, McGuire received his second M.D. from the Medical College of Virginia. When the Civil War began he joined the Confederate army. Appointed medical director for the troops then under the command of Thomas J. "Stonewall" Jackson, he served throughout the war and was the attending physician at Jackson's death.[3]

After the war, McGuire practiced medicine in Richmond and from 1865 to 1878 held the chair of surgery at the Medical College of Virginia. In 1883 he founded Saint Luke's Home for the Sick, which also operated a training school for nurses, and in 1893 he was a founder of what became the University College of Medicine, where he was professor of surgery. One of the most respected physicians in the South, McGuire published widely in the medical literature. He was president of the Richmond Academy of Medicine in 1869, of the Association of Medical Officers of the Army and Navy of the Confederacy in 1875, of the Medical Society of Virginia in 1881, of the American Surgical Association in 1887, of the Southern Surgical and Gynecological Association in 1889, and of the American Medical Association in 1893. Hunter Holmes McGuire died in Richmond on 19 September 1900 and was buried in Hollywood Cemetery.[4]

Shortly after his death, friends formed the Hunter McGuire Memorial Association "for the purpose of erecting a suitable monument to commemorate his public and professional services to his State and to his community." The committee offered the commission to Couper, who chose to depict McGuire seated and leaning slightly forward, as if listening to a patient. In 1902, the General Assembly authorized the memorial association to erect the statue on the Capitol grounds, "provided, that the Commonwealth

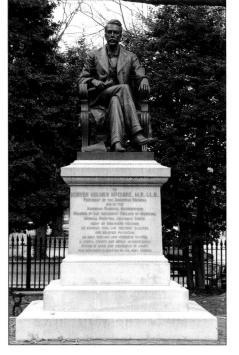

shall not be put to any expense in connection with the erection of such statue."[5]

On 7 January 1904, the association presented Couper's statue of McGuire to Governor Andrew Jackson Montague, who accepted it on behalf of the Commonwealth. Confederate veterans, members of Richmond's militia companies, and faculty and students from the University College of Medicine and the Medical College of Virginia all participated in the procession. One of McGuire's grandsons pulled the string that unveiled the statue. The *Richmond Times-Dispatch* the next day reported that several thousand people attended the ceremony and that "every window from the big buildings located near was full— the Capitol, the City Hall, the Powhatan Hotel."[6]

BCB

NOTES

1. Greta Elena Couper, *An American Sculptor on the Grand Tour: The Life and Works of William Couper (1853–1942)* (Los Angeles: TreCavalli Press, 1988), 5–7, 20–21, 28, 32, 34–35, 40, 44, 54, 89, 113.

2. Lorado Taft, *History of American Sculpture* (New York: The Macmillan Company, 1903), 418–424 (quotation on 423); Couper, *An American Sculptor on the Grand Tour*, 48, 101–104; "John Smith Monument to Be Unveiled at Jamestown," *Washington Post*, 9 May 1909, p. E8.

3. James O. Breeden, "McGuire, Hunter Holmes," *American National Biography* (New York and Oxford, Eng.: Oxford University Press, 1999), 15:78.

4. Ibid., 78–79.

5. *Ceremonies and Addresses Attending the Presentation of a Statue of Hunter Holmes McGuire by the Hunter McGuire Memorial Association, and Its Acceptance by the State, at Richmond, Va., January 7, 1904* (Richmond: Published under the Auspices of R. E. Lee Camp, No. 1, Confederate Veterans, 1904), 7 (1st quotation); *Acts and Joint Resolutions Passed by the General Assembly of the State of Virginia, during the Session of 1901–2* (Richmond: J. H. O'Bannon, Superintendent of Public Printing, 1902), 215 (2d quotation).

6. "Scene at Unveiling of the Monument to Dr. McGuire: Takes His Place with the Immortals," *Richmond Times-Dispatch*, 8 January 1904, pp. 1–2.

REFERENCES

Breeden, James O. "McGuire, Hunter Holmes." *American National Biography*, 15:78–79. New York and Oxford, Eng.: Oxford University Press, 1999.

Ceremonies and Addresses Attending the Presentation of a Statue of Hunter Holmes McGuire by the Hunter McGuire Memorial Association, and Its Acceptance by the State, at Richmond, Va., January 7, 1904. Richmond: Published under the Auspices of R. E. Lee Camp, No. 1, Confederate Veterans, 1904.

Couper, Greta Elena. *An American Sculptor on the Grand Tour: The Life and Works of William Couper (1853–1942)*. Los Angeles: TreCavalli Press, 1988.

Hassler, William W. "Dr. Hunter Holmes McGuire: Surgeon to Stonewall Jackson, the Confederacy, and the Nation." *Virginia Cavalcade* 32 (1982): 52–61.

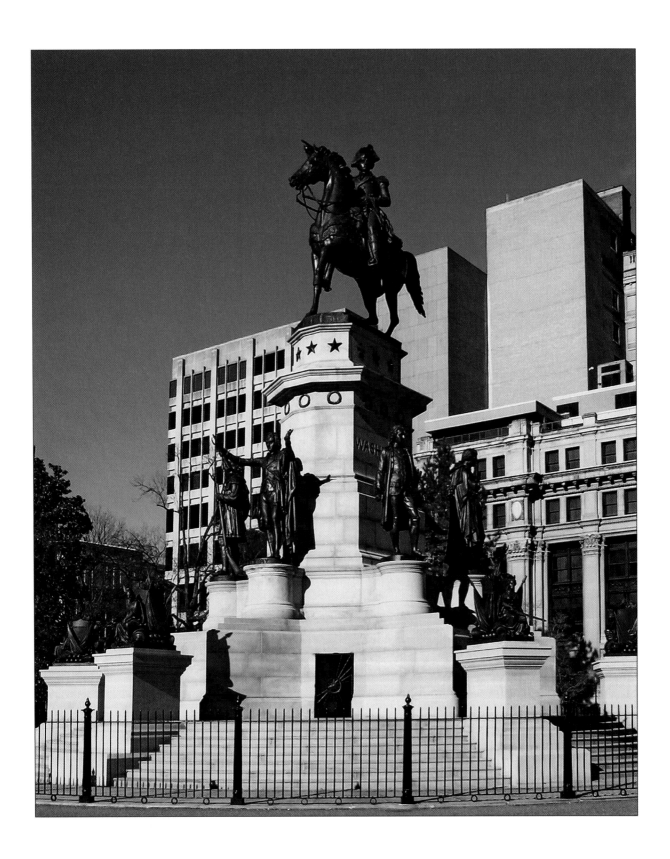

THOMAS CRAWFORD (1814–1857)
RANDOLPH ROGERS (1825–1892)
VIRGINIA'S WASHINGTON MONUMENT

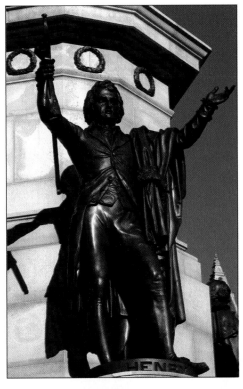

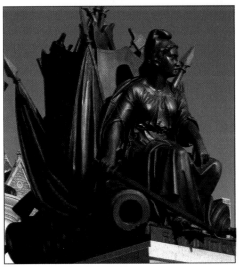

1850–1868

Bronze with granite pedestal

Height approximately 60 feet

Inscriptions: on east and west sides of granite pedestal "WASHINGTON";

on Henry: Base, front "HENRY"; Base, proper right "T. CRAWFORD / INV. ET MOD. / ROME / MDCCCL"; Base, proper left "F. V. MILLER / FUDIT / MUNCHEN / 1853";

on Lewis: Base, front "LEWIS"; Base, proper right "F. V. MILLER / FUDIT / MUNCHEN / 1861"; Base, proper left "RANDOLPH ROGERS / INV. ET MOD. / ROME MDCCCLIX";

on Marshall: Base, front "MARSHALL"; Base, proper right "F. V. MILLER / FUDIT / MUNCHEN / 1860"; Base, proper left "T. CRAWFORD INV. / C. KAUPERT MOD. / ROME / MDCCCLVIII";

on Nelson: Base, front "NELSON"; Base, proper right "F. V. MILLER / FUDIT / MUNCHEN / 1861"; Base, proper left "RANDOLPH ROGERS / INV. ET MOD. / ROME MDCCCLIX";

on Jefferson: Base, front "JEFFERSON"; Base, proper right "T. CRAWFORD / INV. ET MOD. / ROME / MDCCCLII"; Base, proper left "F. V. MILLER / FUDIT / MUNCHEN / 1854";

on Mason: Base, front "MASON"; Base, proper right "F. V. MILLER / FUDIT / MUNCHEN / MDCCCLIX"; Base, proper left "T. CRAWFORD / INV. ET MOD. / ROME / MDCCCLVI";

on Allegorical figures (inscriptions identical): Base, proper right "RANDOLPH ROGERS / INV. ET MOD. / ROME MDCCCLX"; Base, proper left "FERD. V. MILLER / FUDIT MUNCHEN 1868"

Collection of the Commonwealth of Virginia

Born in New York City on 22 March 1814, Thomas Crawford apprenticed himself to a woodcarver, made drawings of works of art at the American Academy of Fine Arts, and studied at the National Academy of Design before joining John Frazee's stoneworks in New York, where he worked with Frazee and sculptor Robert E. Launitz. In 1835 Crawford moved to Rome to study with Danish sculptor Bertel Thorvaldsen and became a leader in the community of American expatriates. During more than two decades he completed twenty-nine portrait busts, more than a hundred ideal works, and eight commissioned public monuments. Crawford modeled the marble figures of *Justice* and *History* and a large allegorical *Progress of Civilization* for the United States Capitol, which was being expanded during the 1850s, and he designed the bronze *Statue of Freedom* for the dome. Thomas Crawford died of cancer in London on 10 October 1857.[1]

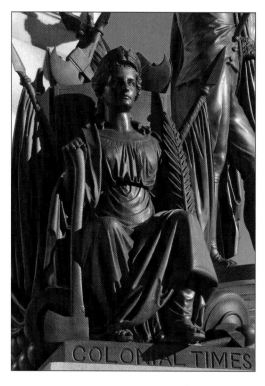

Long before his death in 1799, George Washington had achieved iconic status as the model citizen for the American Republic. Born in Westmoreland County on 22 February 1732, he worked as a surveyor and became an adjutant commander of a Virginia militia district with the rank of major before the age of twenty. In 1753 Washington traveled to the upper Ohio Valley in order to deliver a message from the governor of Virginia to the French outpost there demanding that the French leave British colonial territory. During the ensuing Seven Years', or French and Indian, War, Washington commanded Virginia militiamen and served on the staff of British general Edward Braddock, becoming the most famous military man in the colonies. A member of the House of Burgesses from 1759 until 1775, Washington was a delegate to the Continental Congress in 1774 and 1775. On 15 June of the latter year Congress appointed him a general and commander in chief of the American army.

Washington took command in Boston three weeks later and served without interruption throughout the Revolutionary War, retiring in December 1783. He presided over the Constitutional Convention in Philadelphia in 1787 and in the spring of 1789 was unanimously elected the first president of the United States. Reelected four years later, he served until 4 March 1797, when he returned to Mount Vernon. One of the wealthiest Virginia planters, Washington ordered when he wrote his will that his many slaves be freed following the death of his wife. George Washington died at Mount Vernon on 14 December 1799 and was buried, according to his desire, in a tomb not far from his world-famous house.[2]

Public statues to commemorate Washington's service to his country were considered as early as 1783, when Congress voted to erect an equestrian statue of the general. In 1784, Virginia commissioned a statue of Washington from the French sculptor Jean-Antoine Houdon. In 1816 the Virginia General Assembly voted to erect a funerary monument in Richmond in the hope that Washington's family would allow his remains to be placed in the capital of the Commonwealth, but the family refused. In 1822 the governor Thomas Mann Randolph declared that the Commonwealth would erect a cenotaph monument, or empty tomb, and created a Washington Monument Fund to raise money for the project. By 1832 Virginia found itself in a race with Baltimore, New York, Philadelphia, and Washington, D.C., to erect a monument to Washington. Donations trickled in until 1848 when the fund contained enough money to allow a board of commissioners to announce a design competition and offer a prize of $500.00.[3]

In February 1850 Crawford won the competition to sculpt a large monument to George Washington for the Capitol grounds in Richmond. More than seventy

designs had been submitted by artists, architects, and amateurs. Crawford's design for a bronze equestrian statue also included the standing figures of six significant Virginians, representing events or ideals in the history of the Republic. The artist and the Virginia commissioners eventually selected General Andrew Lewis to represent the colonial campaigns, Patrick Henry the Revolution, George Mason the Declaration of Rights, Thomas Jefferson the Declaration of Independence, Thomas Nelson finance, and John Marshall justice. Crawford's original plan also called for a circle of bronze eagles below the standing figures.[4]

On Washington's Birthday, 22 February 1850, Freemasons from the Richmond lodges laid the five-ton granite cornerstone northwest of the Capitol. Crawford worked on the monument in Rome and in August 1854 shipped the twenty-one-foot-high plaster of the equestrian group to Munich for casting. This statue was a remarkable technical achievement both for Crawford, who designed the horse to balance on two legs, and for Otto von Miller, of the Royal Foundry, who managed to cast the body of the horse in one piece. Crawford's twelve-foot bronze figures of Jefferson and Henry arrived in Richmond in August 1855, and the equestrian group arrived in November 1857 almost simultaneously with the news of Crawford's death. Before he died, Crawford had modeled but not cast the figures of Marshall and Mason. In the largest celebration in the commonwealth to that date, the incomplete monument was unveiled on 22 February 1858, the 126th anniversary of Washington's birth. Four years later the striking image of Washington on horseback became the image for the great seal of the Confederate States of America.[5]

Following Crawford's death, the state government contracted with Randolph Rogers, one of Crawford's col-

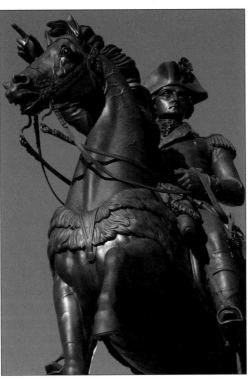

leagues who also lived in Rome, to complete the monument. Rogers was born in Waterloo, New York, on 6 July 1825, grew up in Michigan, and in 1847 moved to New York City in hopes of becoming a skilled wood engraver. The following year he traveled to Florence, Italy, to study with Lorenzo Bartolini, after which he worked for two years in Rome. Rogers spent much of his career in Italy and produced mostly portraits and monuments, although he also created some successful idealized figures. Like Crawford, he did work for the United States Capitol, including its bronze Columbus Doors. Rogers executed numerous commissions for commemorative monuments and achieved considerable respect and renown. Italy's King Umberto I knighted him in 1884. Randolph Rogers died in Rome on 15 January 1892.[6]

Rogers's contract with Virginia required him to finish the Mason and Marshall figures, sculpt the figures of Lewis and Nelson, and create six allegorical trophy groups for the base. Rogers and the commissioners decided to replace the eagles with small sculptural groups, each with an allegorical figure symbolic of the concept associated with the standing figure behind it. The outbreak of the Civil War in 1861 temporarily halted additions to the monument. Rogers wrote to Governor Francis Pierpont in November 1866 that the remaining three figures—Lewis, Marshall, and Nelson—were ready to be shipped to Virginia. Rogers's figures of Virginia patriots for the Washington monument in Richmond are regarded as among his best work.[7]

The work of Crawford and Rogers during the 1850s and 1860s produced one of the city's best-known pieces of public art. Likenesses of all the subjects except Andrew Lewis were taken from portraits or busts executed from life. After thirty-five years of planning, eighteen

years of modeling, casting, and construction, and an expenditure of $259,913.26, the monument was completed with the installation of the final figures in August 1868, an achievement that at the time was little noticed by newspapers or the public.[8]

<div align="center">TLK</div>

<div align="center">❧</div>

NOTES

1. Robert L. Gale, "Crawford, Thomas," *American National Biography* (New York and Oxford, Eng.: Oxford University Press, 1999), 5:708–710. See also Gale, *Thomas Crawford: American Sculptor* (Pittsburgh: University of Pittsburgh Press, 1964).

2. Forrest McDonald, "Washington, George," *American National Biography*, 22:758–766.

3. *Daily Richmond Enquirer*, 13 February 1850; Governor Thomas Mann Randolph to Speaker of the House of Delegates, *Journal of the House of Delegates (1821–1822)*, microfilm 331, p. 195, The Library of Virginia, Richmond. Although Virginia intended to have the first equestrian statue, and the first equestrian Washington, in the United States, it failed on both counts as Virginians simply would not contribute to the monument fund. The first equestrian statue was Clark Mills's *Andrew Jackson*, in Washington, D.C. New York City received the first equestrian Washington, designed by Henry Kirke Brown, in 1856. Lauretta Dimmick, "'An Altar Erected to Heroic Virtue Itself': Thomas Crawford and His *Virginia Washington Monument*," *American Art Journal* 23, no. 2 (1991): 4; H. Nichols B. Clark, "An Icon Preserved: Continuity in the Sculptural Images of Washington," in *George Washington: American Symbol*, ed. Barbara J. Mitnick (New York: Hudson Hills Press in Association with The Museums at Stony Brook and The Museum of Our Natural Heritage, 1999), 45.

4. For Crawford's contracts, see *Calendar of Virginia State Papers and Other Manuscripts from January 1, 1836, to April 16, 1869; Preserved in the Capitol at Richmond*, ed. H. W. Flournoy (Richmond: Commonwealth of Virginia, 1893), 11:25, 27–31, 45–47.

5. Frances W. Saunders, "Equestrian Washington: From Rome to Richmond," *Virginia Cavalcade* 25 (Summer 1975): 7–11; Thomas B. Brumbaugh, "The Evolution of Crawford's 'Washington,'" *Virginia Magazine of History and Biography* 70 (1962): 18–24; Dimmick, "'An Altar Erected to Heroic Virtue Itself,'" 46.

6. Sylvia L. Lahvis, "Rogers, Randolph," *American National Biography* (New York and Oxford, Eng.: Oxford University Press, 1999), 18:771–772. For more information on Rogers and his governmental commissions, see Millard F. Rogers Jr., *Randolph Rogers: American Sculptor in Rome* (Amherst, Mass.: University of Massachusetts Press, 1971).

7. For Rogers's contracts, see Flournoy, *Calendar of Virginia State Papers*, 11:56–60; Rogers to Pierpont, *Journal of the House of Delegates . . . for the Session of 1866–'67* (Richmond: Enquirer, Print., 1866), 12.

8. Brumbaugh, "The Evolution of Crawford's 'Washington,'" 29; Lahvis, "Rogers, Randolph," 772. There is no known likeness of Lewis, for whom Rogers modeled an idealized eighteenth-century frontiersman in a Revolutionary period hunting shirt.

REFERENCES

Brumbaugh, Thomas B. "The Evolution of Crawford's 'Washington.'" *Virginia Magazine of History and Biography* 70 (1962): 3–29.

Dimmick, Lauretta. "'An Altar Erected to Heroic Virtue Itself': Thomas Crawford and His *Virginia Washington Monument*." *American Art Journal* 23, no. 2 (1991): 4–73.

Freeman, Douglas Southall. *George Washington: A Biography*. 7 volumes. New York: Scribner, 1951–1959.

Gale, Robert L. "Crawford, Thomas." *American National Biography*, 5:708–710. New York and Oxford, Eng.: Oxford University Press, 1999.

_____. *Thomas Crawford: American Sculptor*. Pittsburgh: University of Pittsburgh Press, 1964.

Lahvis, Sylvia L. "Rogers, Randolph." *American National Biography*, 18:771–772. New York and Oxford, Eng.: Oxford University Press, 1999.

McDonald, Forrest. "Washington, George." *American National Biography*, 22:758–766. New York and Oxford, Eng.: Oxford University Press, 1999.

Rogers, Millard F., Jr. *Randolph Rogers: American Sculptor in Rome*. Amherst, Mass.: University of Massachusetts Press, 1971.

Virginia. General Assembly. House of Delegates. Select Committee on the Washington Monument. "Report of the Select Committee on the Subject of the Washington Monument." House Doc. No. 56, 1852, pp. 3–93. In *Journal of the House of Delegates of the State of Virginia for the Session of 1852*. Richmond: William F. Ritchie, 1852.

Virginia. Auditor of Public Accounts (1776–1928). Capitol Square Data. Washington Equestrian Statue Records, 1817–1868. Accession 40979. State Government Records Collection, The Library of Virginia, Richmond.

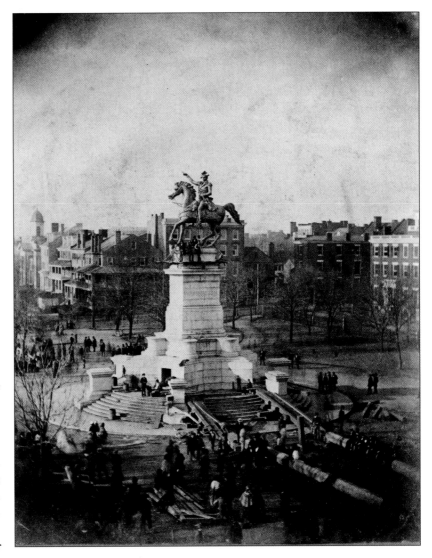

Virginia's Washington Monument SHORTLY AFTER INSTALLATION OF EQUESTRIAN GROUP, 1858. SALT PRINT BY UNIDENTIFIED PHOTOGRAPHER. PRINTS AND PHOTOGRAPHS DIVISION, LIBRARY OF CONGRESS.

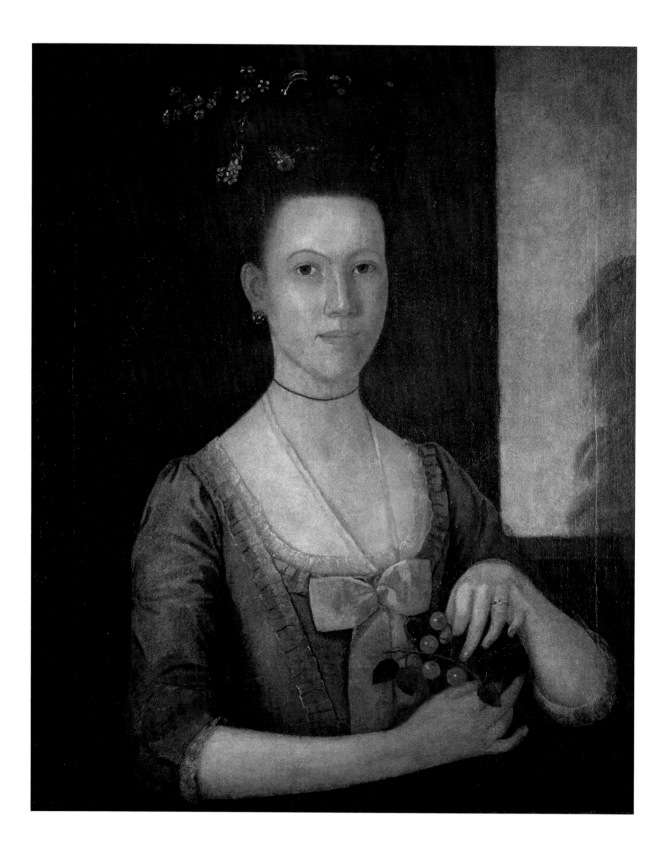

JOHN DURAND (FL. 1765–1782)
ANNA BAIRD (DIED BEFORE 1807)

Ca. 1775–1780
Oil on canvas
30 inches x 25 inches
Collection of the Executive Mansion, gift of the estate of
Martha Spotswood

One of the most elusive artists of the colonial period, John Durand painted portraits in New York, Connecticut, and Virginia, beginning about 1765, the year of his earliest-known signed and dated portrait. The following year, when Durand was in New York, merchant James Beekman recorded paying £19 to "Monsieur Duran for drawing my Six Childrens Pictures." Although Beekman's reference suggests that Durand was French or of French descent, there are no known records of Durand's birth, training, or personal life. Like many other colonial artists, he painted more than portraits. When he was in Virginia in 1770 he advertised his ability to "paint, gild, and varnish, wheel carriages; and put coats of arms, or ciphers, upon them." Several of Durand's New York portraits are of children, suggesting that he hoped to use the portraits as a means to advertise his abilities and to promote a drawing school to parents, which he opened in 1767. That he intended to paint historical scenes is indicated by an advertisement that Durand placed in April 1768 in which he stated that he had "endeavored to qualify himself" in historical painting "from his Infancy." Durand was in New Haven, Connecticut, in 1768, in Williamsburg in 1769, and still in Virginia in June 1770, when he announced in the *Virginia Gazette* that he would travel to sitters' residences to paint portraits "upon very moderate terms, either for cash, short credit, or country produce." He had returned to Connecticut by 1772 but was back in Virginia again by 1775. The last-known reference to Durand appears on a 1782 tax list for Dinwiddie County.[1]

Very little is known about Anna Baird, whose portrait Durand painted likely on one of his visits to Virginia. She married Captain Joseph Weisiger, a member of the Prince George Light Infantry, on 7 March 1788. He died six years later at age thirty-six, leaving no children. In 1797, "Mrs. Ann Weisiger" was listed as owning 41½ acres of land in Prince George County. She probably died about ten years later. After 1807 the tax record lists her

estate as the owner of the property. In her portrait, Baird awkwardly holds cherries, perhaps suggesting a gentle temper. Her hair is swept up and adorned with flowers. Although unsigned, the portrait displays Durand's characteristic use of line to define shape, an attention to detail and clothing, and an emphasis on color. There is a flatness to his three-dimensional figures, with little use of light and shadow to model faces, although he often captures the sheen of satin clothing worn by his sitters. William Dunlap, in his *History of the Rise and Progress of the Arts of Design in the United States* (1834), quoted Robert Sully, his informant about early Virginia painting, that Durand's portraits were "hard and dry, but appear to have been strong likenesses."[2]

The Executive Mansion received the portrait in 1977 from the estate of Martha Spotswood, of Petersburg.

BCB

NOTES

1. Franklin W. Kelly, "The Portraits of John Durand," *The Magazine Antiques* 122 (1982): 1080–1087, quoting Beekman on 1080 (1st quotation); *Virginia Gazette* (Williamsburg, Va.: Alexander Purdie and John Dixon), 21 June 1770 (2d quotation); *New York Gazette or Weekly Post Boy* (New York), 18 April 1768 (3d quotation); *Virginia Gazette* (Williamsburg, Va.: Alexander Purdie and John Dixon), 21 June 1770 (4th quotation); Kelly, "The Portraits of John Durand," 1080–1087, especially 1085; Virginia, Auditor of Public Accounts, Personal Property Taxes, Dinwiddie County, 1782, The Library of Virginia, Richmond.

2. Benjamin Boisseau Weisiger III, *The Weisiger Family: An Account of Daniel Weisiger, the Immigrant, of Henrico and Chesterfield Counties, Virginia, and His Descendants* (Richmond: B. B. Weisiger, 1983), 31 (1st quotation); William Dunlap, *History of the Rise and Progress of the Arts of Design in the United States* (New York: George P. Scott and Co., 1834), 2:144, quoting Robert Matthew Sully (2d quotation). The authors wish to thank Linda Baumgarten, Curator of Textiles at the Colonial Williamsburg Foundation, for helping to date the portrait based on details of Baird's costume.

REFERENCES

Kelly, Franklin W. "The Portraits of John Durand." *The Magazine Antiques* 122 (1982): 1080–1087.

Weisiger, Benjamin Boisseau, III. *The Weisiger Family: An Account of Daniel Weisiger, the Immigrant, of Henrico and Chesterfield Counties, Virginia, and His Descendants.* Richmond: B. B. Weisiger, 1983.

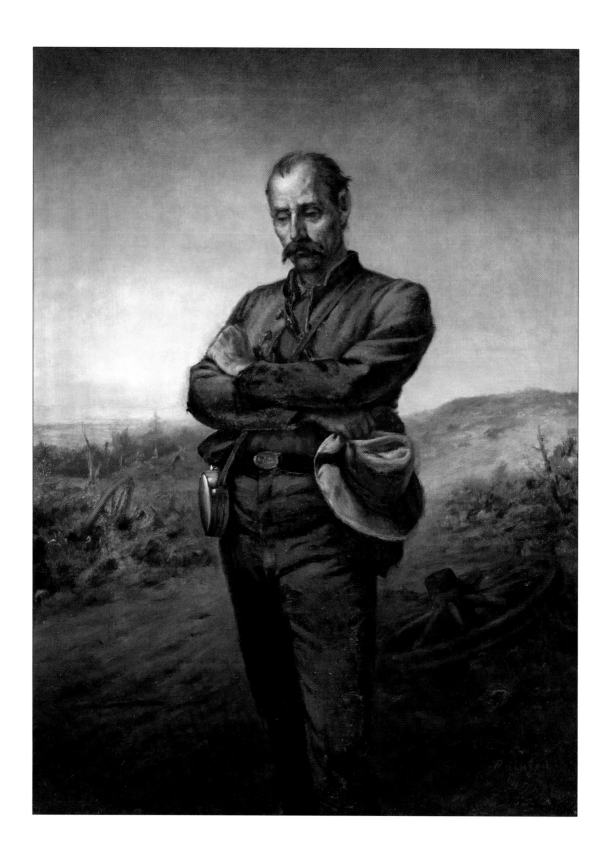

JOHN ADAMS ELDER (1833–1895)
APPOMATTOX

1887
Oil on canvas
26 inches x 17⅞ inches
Inscribed at lower right "Painted by J. A. Elder"
Collection of the Library of Virginia

John Adams Elder was born in Fredericksburg, Virginia, on 3 February 1833 and as a young man caught the attention of John Minor, a wealthy Fredericksburg citizen who encouraged his artistic talent. As a result, Elder was able to study under Emanuel Leutze, a German artist then working in Fredericksburg. With Minor's help, Elder traveled to New York, where he studied under Daniel Huntington, and in 1851 he accompanied Leutze to Düsseldorf to study at the Kunstakademie. Elder won the academy's Prix de Rome but declined the award and, consequently, the chance to study in Rome. He opened a studio in New York in 1856 but soon returned to Virginia, where he divided his time between Fredericksburg and Richmond. After the Civil War began, he worked as a draftsman in the War Department of the Confederacy and later as an aide in the field. He was in Petersburg at the time of the Battle of the Crater, where he sketched the scene. His painting of the horrifying battle was destroyed in 1865, but he completed a second painting of the subject in 1869, now in the collection of the Commonwealth Club in Richmond.[1]

After the war Elder painted portraits of many distinguished Virginians, as well as genre pieces such as *The Scout's Return*, *Waiting for the Boat*, and *Last of His Tribe*. He received a commission from William Wilson Corcoran, of Washington, D.C., to paint three-quarter-length portraits of Thomas J. "Stonewall" Jackson and Robert E. Lee and later traveled to Biloxi, Mississippi, to paint a portrait of Jefferson Davis, the former president of the Confederate States of America. While there, Elder contracted malaria. He returned to Fredericksburg and in 1889 suffered a stroke that rendered him unable to paint any longer. John Adams Elder died in Fredericksburg on 24 February 1895.[2]

According to Elder's friend Raleigh T. Daniel, the figure in *Appomattox* is from a larger work planned to depict Lee's farewell to the Army of Northern Virginia.

Daniel explained in a letter to the *Richmond Times-Dispatch* that *Appomattox*

represents in one typical figure the South in its overthrow—not in the persons of its leaders, but in one of that honored file who, in thousands, returned to their ruined homes to face the future, with no ray from the past to inspire or guide them. The imposing figure stands alone on a desolate field, "cast down, but not destroyed." In the resolute face, in the firm pose of the foot, the tense grasp of the hand, which closes on no weapon save his own right arm, there is vigor yet. And in this image of defeat there is all the life and purpose which have restored the overturned civilization of our country, and from the ruins of war have raised a structure of which we are justly proud.[3]

Elder painted a full-length version in 1887 that the Richmonder Joseph Bryan purchased. It was the model for the bronze figure of a Confederate soldier, executed by Casper Buberl, for R. E. Lee Camp, No. 2, United Confederate Veterans, in 1888. The bronze was cast by the Henry Bonnard Company in New York and dedicated in Alexandria in May 1889. Elder also painted a three-quarter-length version of *Appomattox*, which, Daniel wrote, "being only a three-quarter length, loses somewhat of the dignity of pose that characterizes the other one, while the background of hillside, which raises the sky line nearly to the head, detracts from the desolate effect of the barren level plain of the original."[4]

The General Assembly's Joint Committee on the Library instructed Henry W. Flournoy, secretary of the commonwealth and ex officio state librarian, to purchase the three-quarter-length version of the painting in 1887. *Appomattox* was on display in the Executive Mansion for many years until Governor William Hodges Mann ordered in January 1914 that it be returned to the State Library. In addition to *Appomattox*, the state art collection includes several portraits by

Elder, including those of Robert E. Lee, of Thomas Jefferson (after Gilbert Stuart), and of Matthew Fontaine Maury.[5]

BCB

—

NOTES

1. Margaret Coons, "A Portrait of His Times," *Virginia Cavalcade* 16 (Spring 1967): 15–31; Edward Morris Davis III, *A Retrospective Exhibition of the Work of John Adams Elder, 1833–1895* (Richmond: Virginia Museum of Fine Arts, 1947).

2. Coons, "A Portrait of His Times," 15–31; Davis, *A Retrospective Exhibition of the Work of John Adams Elder*; "Mr. John A. Elder Passes Over the River," obituary in *Fredericksburg Daily Star*, 25 February 1895, p. 3.

3. R[aleigh] T. D[aniel], "Elder's Painting, 'Appomattox,'" *Richmond Times-Dispatch*, 14 February 1914, p. 4.

4. Ibid.

5. "Report of H. W. Flournoy, General Librarian, to Joint Library Committee," Senate Doc. No. 21, *Journal of the Senate . . . Held . . . December 7, 1887* (Richmond: A. R. Micou, Superintendent of Public Printing, 1887), 2; Earl Gregg Swem, "A List of the Portraits and Pieces of Statuary in the Virginia State Library, With Notes and Illustrations," *Bulletin of the Virginia State Library* 13 (1920): 28.

REFERENCES

Coons, Margaret. "A Portrait of His Times." *Virginia Cavalcade* 16, no. 4 (Spring 1967): 15–31.

D[aniel], R[aleigh] T. "Elder's Painting, 'Appomattox.'" *Richmond Times-Dispatch*, 14 February 1914, p. 4.

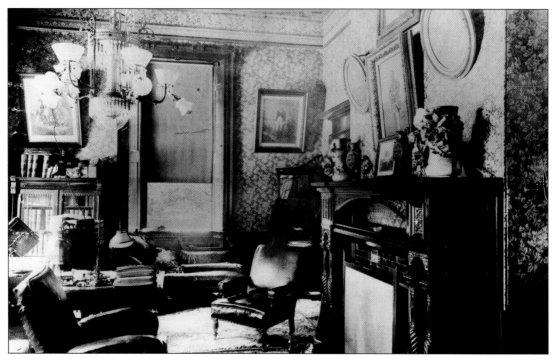

Appomattox IN GOVERNOR CHARLES T. O'FERRALL'S OFFICE AT THE EXECUTIVE MANSION, CA. MID-1890S. EDYTHE CARTER BEVERIDGE, PHOTOGRAPHER. COURTESY OF VALENTINE RICHMOND HISTORY CENTER.

Davis, Edward Morris, III. *A Retrospective Exhibition of the Work of John Adams Elder, 1833–1895*. Richmond: Virginia Museum of Fine Arts, 1947.

Gunter, Donald Wilson. "John Adams Elder." In *The Common Wealth: Treasures from the Collections of the Library of Virginia*. Edited by Sandra Gioia Treadway and Edward D. C. Campbell Jr., 268. Richmond: The Library of Virginia, 1997.

Happel, Ralph. "John A. Elder, Confederate Painter." *Commonwealth* 4 (August 1937): 23–25.

Simms, L. Moody, Jr. "John A. Elder, Memorial Artist of the Confederacy." *Lincoln Herald* 74, no. 1 (Spring 1972): 29–33.

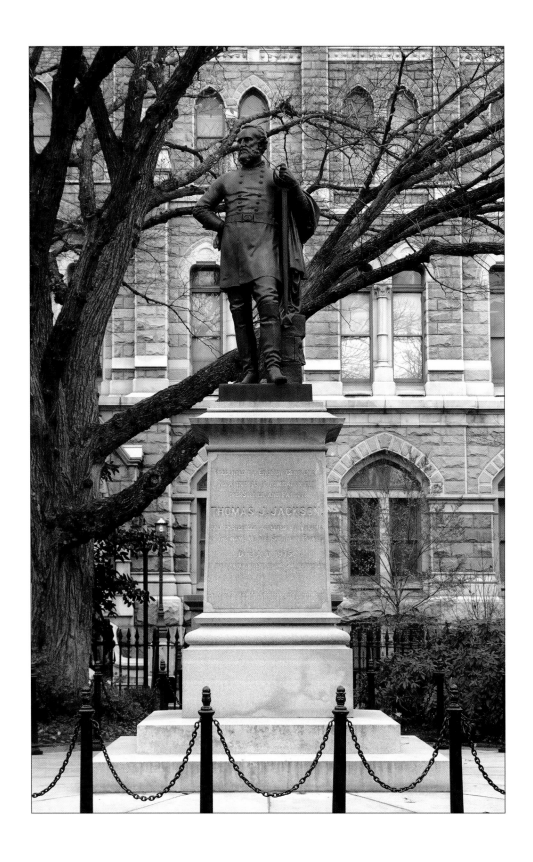

JOHN HENRY FOLEY (1818–1874)
GENERAL THOMAS J. "STONEWALL" JACKSON (1824–1863)

1873

Bronze with granite pedestal

Height 17 feet

Inscriptions: on base at proper left "J. H. FOLEY, R.A. / Sculptor / LONDON 1873"; on base at proper right "R. MASEFIELD & Co / Founders / LONDON"; on front of pedestal "Presented by English Gentlemen / as a tribute of admiration for / the Soldier and Patriot, / Thomas J. Jackson, / and gratefully accepted by Virginia / in the name of the Southern People. / Done A. D. 1875, / in the Hundredth Year of the Commonwealth. / *Look! There is Jackson standing like a stonewall*."

Collection of the Commonwealth of Virginia, gift of citizens of England

Born in Dublin, Ireland, on 24 May 1818, John Henry Foley studied at the Royal Dublin Society and at the Royal Academy in London, and worked as a studio assistant to sculptor William Behnes. Foley became an associate of the Royal Academy in 1849 and a full member in 1857. He exhibited works at the Royal Academy exhibitions from 1839 until 1861. In 1844 Foley submitted a figure to a statuary competition for the new Houses of Parliament, for which he received a commission. During that decade he completed statues of several notable historic British leaders and in 1855 created a monument to Irish patriot Daniel O'Connell that stands more than thirty-nine feet tall. An acclaimed sculptor noted for his technical skill and his originality, Foley was characterized as a "very conscientious and fastidious workman." When Queen Victoria commissioned a monument to her husband, Albert, the Prince Consort (1819–1861), Foley contributed two of the figures to be cast—Asia, one of the four monumental groups surrounding the Albert Memorial, and the figure of the Prince Consort himself. John Henry Foley died at Hampstead on 27 August 1874.[1]

One of the last commissions Foley completed was for a statue of Confederate lieutenant general Thomas J. "Stonewall" Jackson, who was born in Clarksburg, Virginia (now West Virginia), on 21 January 1824, graduated from the United States Military Academy in 1846, and won distinction for his coolness under fire in the Mexican War. Jackson retired from the army in 1851 and taught at the Virginia Military Institute until 1861. During the first two years of the Civil War, Jackson was the Confederacy's most celebrated field commander, earning the nickname "Stonewall" at the First Battle of Manassas on 21 July 1861. The rapid marches that his brigade made in the Shenandoah Valley and the hard fighting in which it was engaged made him world famous. Stonewall Jackson died on 10 May 1863, several days after being accidentally shot by his own soldiers while returning to Confederate lines after a night reconnaissance during the Battle of Chancellorsville.[2]

As early as 1 June 1863, a group of ten English gentlemen, including five members of Parliament, proposed that a statue of Jackson be made and placed in Richmond as "testimony of England's admiration for a truly noble character." Commissioning Foley to produce a marble statue, seven feet tall, on a granite pedestal, the group stated, "It is not at all intended that Subscriptions to the Statue should imply any opinion on the merits of the American struggle. They will be taken solely and simply as a recognition of the rare personal merit of General Jackson." It is unclear when the decision was made to cast the statue in bronze. The inscription on the pedestal, which Foley also designed, originally contained General Robert E. Lee's order of the day announcing Jackson's death to the troops.[3]

Photographs of Jackson were available in London, but at the request of the committee and Foley, James

Murray Mason, a Virginian and commissioner for the Confederate government in London, wrote to the Confederate secretary of state Judah P. Benjamin requesting "information as to his height and the general mold of his form." Foley completed the work in 1873, and after his death his assistants provided Foley's sketches for the pedestal, which the Westham Granite Company, of Virginia, produced.[4]

On 31 March 1875, the General Assembly appropriated $10,000 to cover the installation expenses of the statue, "presented to the state by citizens of England." In a joint resolution, the assembly directed that the statue be placed "on some conspicuous spot within the grounds of the capitol, to be preserved and cherished by the people of Virginia, as a memorial of its distinguished subject, and of the noble sympathies of its honored donors." The statue was unveiled on 26 October 1875 in a ceremony funded largely through private donations. The general's widow, Mary Anna Morrison Jackson, along with Governor James Lawson Kemper and many other Confederate veterans, attended.[5]

BCB

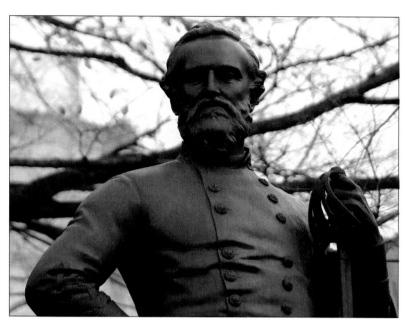

NOTES

1. William Cosmo Monkhouse, "Foley, John Henry," *Dictionary of National Biography* (New York: Macmillan and Co., 1889), 19:354 (quotation); Mark Stocker, "Foley, John Henry," *Oxford Dictionary of National Biography* (New York and Oxford, Eng.: Oxford University Press, 2004), 20:211–212.

2. James I. Robertson Jr., "Jackson, Thomas Jonathan," *American National Biography* (New York and Oxford, Eng.: Oxford University Press, 1999), 11:776–778; Robertson, *Stonewall Jackson: The Man, the Soldier, the Legend* (New York: Macmillan Publishing USA, 1997), 47–70.

3. "A British Monument to Jackson," *Index* (London, Eng.), 24 June 1863, p. 136 (1st quotation); advertisement for monument, *Index*, 17 September 1863, p. 336 (2d quotation).

4. Edwin Denby and Harry Kidder White, eds., *Official Records of the Union and Confederate Navies in the War of the Rebellion* (Washington, D.C.: Government Printing Office, 1922) ser. 2, vol. 3, pp. 824–827 (quotation on 825).

5. *Acts and Joint Resolutions Passed by the General Assembly of the State of Virginia, at the Session of 1874–1875* (Richmond: R. F. Walker, Supt. Public Printing, 1875), 409 (1st quotation), 453 (2d quotation). The *Richmond Daily Dispatch* devoted both its 26 October and 27 October 1875 issues to the unveiling of the statue.

REFERENCES

Cullop, Charles P. "English Reaction to Stonewall Jackson's Death." *West Virginia History* 29 (1967): 1–5.

Monkhouse, William Cosmo. *The Works of John Henry Foley, Sculptor*. London: Virtue, Spalding & Co., 1875.

Official Records of the Union and Confederate Navies in the War of the Rebellion. Compiled by Edwin Denby and Harry Kidder White, ser. 2, vol. 3, pp. 824–827. Washington, D.C.: Government Printing Office, 1922.

Read, Benedict. "John Henry Foley." *Connoisseur* 186 (1974): 262–271.

Robertson, James I., Jr. "Jackson, Thomas Jonathan." *American National Biography*, 11:776–778. New York and Oxford, Eng.: Oxford University Press, 1999.

————. *Stonewall Jackson: The Man, the Soldier, the Legend*. New York: Macmillan Publishing USA, 1997.

Stocker, Mark. "Foley, John Henry." *Oxford Dictionary of National Biography*, 20:211–212. New York and Oxford, Eng.: Oxford University Press, 2004.

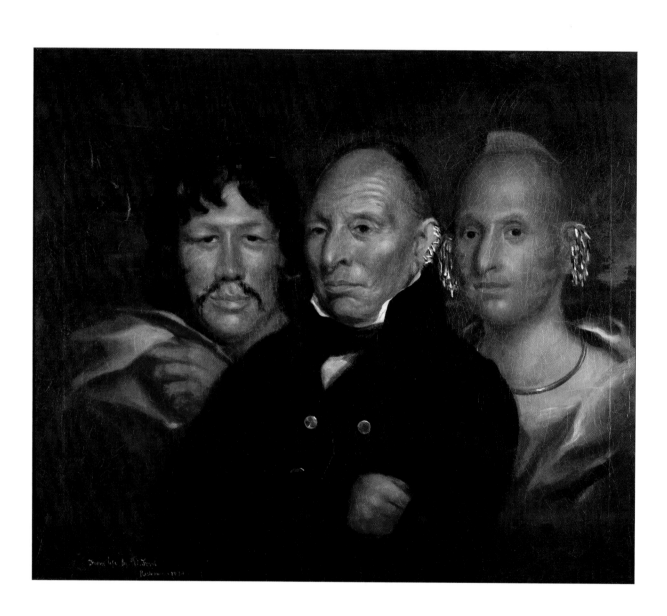

JAMES WESTHALL FORD
(1806–1868)
THE PROPHET WABOKIESHIEK,
BLACK HAWK, AND NASHEASKUK

1833
Oil on canvas
30 inches x 35 inches
Inscribed at lower left "From life by J W Ford /
Richmond 1833"
Collection of the Library of Virginia

Born in Pennsylvania in 1806, James Westhall Ford arrived in Virginia in 1823 to paint a portrait of Martha Jefferson Randolph, daughter of Thomas Jefferson. Writing a letter of recommendation for the artist, Jefferson noted that Ford was "a portrait painter by profession. . . . His good execution, and the reasonableness of his terms render him worthy of encouragement and patronage." Ford used his connections with Jefferson and James Monroe to obtain commissions for portraits from congressmen when he was in Washington in 1823 and from private citizens in Virginia. Although he painted briefly in Raleigh, North Carolina, in 1823, Ford enjoyed his greatest success in Virginia from 1825 until 1859. With the outbreak of the Civil War, Ford returned to Philadelphia where he died on 27 December 1868.[1]

The conflict of 1832, sometimes called the Black Hawk War, resulted from decades of white settlement encroaching on Sauk and Fox land in what is now Illinois. In the spring of 1832, Black Hawk, or Makataimeshekiakiak, a Sauk warrior, defied government demands that he and other Sauk withdraw west of the Mississippi River. Territorial and federal troops mustered to face the Indians in a series of skirmishes that ended in August when Black Hawk surrendered. The Indian leaders were imprisoned for a year. Government officers escorted Black Hawk and his group on a tour of the major East Coast cities after they were released from Fort Monroe on 4 June 1833. The trip was intended to impress on them the futility of continuing to fight against the United States. In August 1833, the Indians returned to Illinois, where Black Hawk lived along the Iowa River. He made a second trip east in 1837 as part of a delegation that sold more than one million acres of land to the federal government. Black Hawk then settled along the Des Moines River, where he died on 3 October 1838.[2]

While en route to Fort Monroe, the group arrived in Richmond on 28 April 1833, where Ford painted three portraits of Black Hawk: one of him alone; a second with his son, Nasheaskuk (Whirling Thunder), and Wabokieshiek, also known as The Prophet; and the third of Black Hawk and The Prophet. Ford advertised in the 17 May 1833 issue of the *Richmond Whig and Public Advertiser* that the paintings and a "full length likeness" of Black Hawk were available for public viewing at the "Painting Room, opposite the Eagle Hotel" for an admission price of twenty-five cents. While the Sauk were in federal custody, several other artists, including John Wesley Jarvis, Robert Matthew Sully, George Catlin, and Charles Bird King, also painted their portraits.[3]

Ford's portraits of the Sauk amply demonstrate the artist's muted palette and loose brushwork. Black Hawk, his face set in resignation, is shown wearing the European-style jacket that President Andrew Jackson insisted that he don to show the dominance of the American government over the Sauk, Fox, and Winnebago. The jacket is at odds with Black Hawk's pierced ears. Nasheaskuk, described by the newspapers as resembling Apollo, wears his native garments, including face paint and elaborate ear piercings. Ford depicted The Prophet, half Sauk and half Winnebago and standing more than six feet tall, with long hair and a mustache, an unusual Indian adornment.[4]

The provenance of the Library of Virginia's painting of Black Hawk is not known, but it was listed in the Library's first inventory of its art, published in 1906.[5]

BCB

33

NOTES

1. Thomas Jefferson letter of recommendation, 1 September 1823, Papers of James Westhall Ford, 1804–1874, Accession MSS 6073, Special Collections Department, University of Virginia Library, Charlottesville, Va.; Mary Givens Kane, "James Westhall Ford," *The Magazine Antiques* 70 (August 1956): 136–138.

2. Donald Jackson, ed., *Black Hawk: An Autobiography* (Urbana: University of Illinois Press, 1964), 1–9, 15, 155–156.

3. Sandra Gioia Treadway, "Triumph in Defeat: Black Hawk's 1833 Visit to Virginia." *Virginia Cavalcade* 35 (1985): 4–17. The double portrait of Black Hawk and The Prophet is in the collection of the Valentine Richmond History Center. The single portrait of Black Hawk is unlocated. The Sully portrait of Black Hawk is in the Virginia Historical Society, and Sully's portraits of The Prophet and Whirling Thunder are in the Wisconsin Historical Society, Madison. Painted in 1832, while the Indians were incarcerated at Jefferson Barracks near Saint Louis, Catlin's portraits of Black Hawk and the Sauk are in the collection of the Smithsonian American Art Museum. Catlin also painted a group portrait of Black Hawk and four other Sauk, a copy of which is in the Paul Mellon Collection of the National Gallery of Art, Washington, D.C. John Wesley Jarvis's double portrait of Black Hawk and Whirling Thunder is in the Gilcrease Museum, Tulsa, Oklahoma. Thomas L. McKenney, commissioner of Indian Affairs, hired Charles Bird King to paint portraits of the Indians to document their appearance in Washington, D.C. McKenney and James Hall later published King's portraits in three volumes of colored lithographs in the *History of the Indian Tribes of North America* between 1836 and 1844.

4. Treadway, "Triumph in Defeat," 8; Joan Elliott Price, "Robert Sully's Nineteenth-Century Paintings of Sauk and Winnebago Indians," *Wisconsin Academy Review* 45, no. 1 (Winter 1998–1999): 26.

5. *Third Annual Report of the Library Board of the Virginia State Library, 1905–1906, To Which is Appended the Third Annual Report of the State Librarian* (Richmond: Davis Bottom: Superintendent of Public Printing, 1906), 33.

ADVERTISEMENT FOR FORD'S PAINTINGS, *Richmond Whig and Public Advertiser*, 17 May 1833

REFERENCES

Ford, James Westhall, Papers of, 1804–1874. Accession MSS 6073. Special Collections Department, University of Virginia Library, Charlottesville, Va.

Jackson, Donald, ed. *Black Hawk: An Autobiography.* Urbana: University of Illinois Press, 1964.

Kane, Mary Givens. "James Westhall Ford." *The Magazine Antiques* 70 (August 1956): 136–138.

Treadway, Sandra Gioia. "Triumph in Defeat: Black Hawk's 1833 Visit to Virginia." *Virginia Cavalcade* 35 (1985): 4–17.

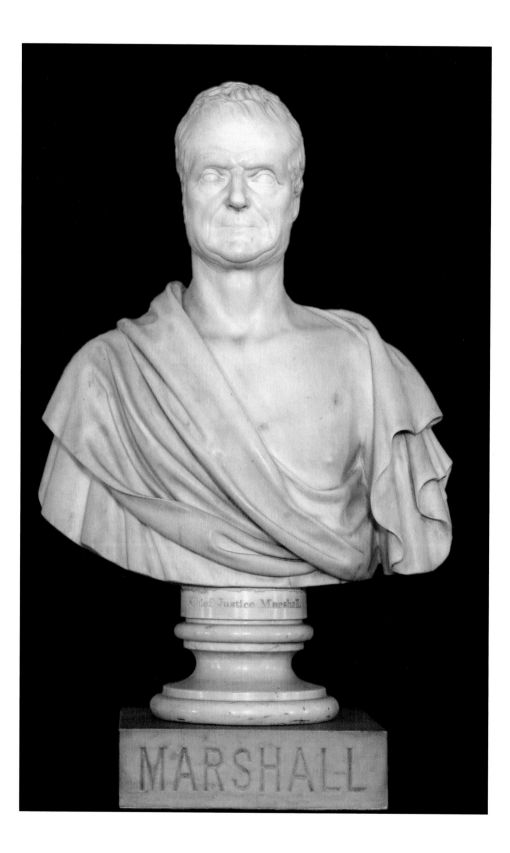

JOHN FRAZEE (1790–1852)
JOHN MARSHALL (1755–1835)

1850
Marble
Height 28 inches
Inscribed on back "J. Fraxee [*sic*] Sculp.[r]—1850."
Inscribed on front of plinth "Chief Justice Marshall"
Collection of the Commonwealth of Virginia

John Frazee's career as a sculptor was a rags-to-riches story. Born on 18 July 1790, in Rahway, New Jersey, he was the son of a carpenter and worked as a bricklayer and in a tavern before being hired as a stonecutter. In 1814 he purchased a stonecutting shop and four years later opened a marble yard in Brooklyn with his brother, William Frazee. In 1829, Frazee accepted Robert E. Launitz as his assistant, and the two formed a partnership early in the 1830s. Launitz, the nephew of sculptor Edouard Launitz and student of Danish sculptor Bertel Thorvaldsen, was a capable artist. Until the dissolution of their partnership in 1837, the firm of Frazee and Launitz enjoyed considerable patronage from New Yorkers.[1]

From 1819 to 1823, Frazee concentrated on decorative mantelpieces and gravestones and then turned to cutting portrait busts. His first bust was a posthumous likeness of John Wells of New York (begun in 1824 and completed in 1825), based on profiles of the deceased. William Dunlap, an early chronicler of American art, believed it to be the first marble bust carved by a native-born American artist. In 1831 Frazee received a commission to make a bust of John Jay, a jurist and statesman. The success of the Jay bust led to other commissions in New York and Boston. Frazee was a founding member of the National Academy of Design in 1826 and exhibited at its annual exhibitions from 1826 until 1841. Frazee was an able artist and, because he was one of the first professional sculptors in the United States, his studio was a magnet for aspiring sculptors, including Thomas Crawford who later designed Virginia's equestrian monument to George Washington. In 1833 Frazee sculpted busts of the mathematician and astronomer Nathaniel Bowditch and lawyer and statesman Daniel Webster for the Boston Athenaeum. The following year the Athenaeum commissioned him to execute a marble bust of John Marshall, chief justice of the Supreme Court of the United States.[2]

In addition to sculpture, Frazee was active in New York politics. In 1830 the Working Men of New York, a group that eschewed political affiliation but wanted "public offices filled by . . . plain practical men," nominated him for Congress. Five years later he took over the design and construction of the New York Customs House (completed in 1842) and later contracted a paralysis, perhaps rheumatoid arthritis, that effectively ended his career as a sculptor. He was an assistant customs officer until he retired in 1847. John Frazee died at Crompton Mills, Rhode Island, on 25 February 1852.[3]

John Marshall was born in Prince William (now Fauquier) County, Virginia, on 24 September 1755. In 1775 he volunteered to serve in the army, rising to the rank of colonel and spending the winter of 1777–1778 with the Continental army at Valley Forge. His legal education consisted of reading law books and briefly studying with George Wythe at the College of William and Mary. Marshall was admitted to the bar in 1780 and for the next twenty years was one of the best and most successful attorneys in central Virginia. He developed an ability to focus on and address the issues in clear language. Marshall also gained a reputation for adherence to a strict republican ideal of subordinating self-interest to the public good, controlling oneself by reason, and maintaining a sense of duty. He was active in politics, representing Fauquier County in the House of Delegates in 1782, Henrico County for the 1787–1788 session, and the city of Richmond from 1795 to 1797. He also served on the Council of State from 1782 to 1784 and was a member of the Convention of 1788, during which he argued and voted for ratification of the Constitution of the United States. In 1797 Marshall went to France as an envoy extraordinary and minister plenipotentiary. He was secretary of state during the final months of John Adams's administration, and on 20 January 1801 Adams nominated him as chief justice.

Marshall held the office for thirty-four years. During his long and influential tenure the Supreme Court established the principle of judicial review and issued a series of decisions that enforced the supremacy of national over state laws and enlarged the scope of congressional authority. He was also a delegate to the 1829–1830 Virginia Constitutional Convention. John Marshall died in Philadelphia on 6 July 1835 and was buried in Shockoe Cemetery in Richmond.[4]

At the behest of the Boston Athenaeum, Frazee traveled to Richmond and in May 1834 took Marshall's measurements and made a model. According to Frazee, he was "met with a frank and friendly reception" from the chief justice. Frazee completed the marble bust in August 1835, one month after Marshall died. He also made at least seven plaster copies, and, in addition to the marble bust for the Boston Athenaeum, he carved at least three other copies in marble, of which Virginia's copy is one. Frazee's bust of Marshall was considered an excellent likeness, depicting the chief justice as the active seventy-eight-year-old man that he then was. The Virginia bust varies slightly from the Athenaeum bust in that the drapery has been pulled higher onto Marshall's chest.[5]

It is unclear when the bust entered the state's collection.

BCB

—◆—

NOTES

1. John Frazee, "The Autobiography of Frazee, the Sculptor," *North American Magazine* 5 (1835): 395–403, and 6 (1835): 1–22.

2. William Dunlap, *History of the Rise and Progress of the Arts of Design in the United States* (New York: George P. Scott and Co., 1834), 2:269; Thomas Seir Cummings, *Historic Annals of the National Academy of Design . . . from 1825 to the Present Time* (Philadelphia: George W. Childs, Publisher, 1865), 28, 230; Andrew Oliver, *The Portraits of*

John Marshall (Charlottesville: University Press of Virginia, 1977), 171–178.

3. *Workingman's Advocate* (New York), 18 September (quotation), 23 October 1830; Frederick S. Voss, *John Frazee, 1790–1852, Sculptor* (Washington, D.C., and Boston: The National Portrait Gallery and The Boston Athenaeum, 1986), 43–53.

4. Charles F. Hobson, "Marshall, John," *American National Biography* (New York and Oxford, Eng.: Oxford University Press, 1999), 14:564–571.

5. Frazee, "The Autobiography of Frazee," 20; Voss, *John Frazee*, 90–92.

REFERENCES

Dunlap, William. *History of the Rise and Progress of the Arts of Design in the United States*, 2:266–269. New York: George P. Scott and Co., 1834.

Frazee, John. "The Autobiography of Frazee, the Sculptor." *North American Magazine* 5 (1835): 395–403, and 6 (1835): 1–22.

Hobson, Charles F. "Marshall, John." *American National Biography*, 14:564–571. New York and Oxford, Eng.: Oxford University Press, 1999.

Oliver, Andrew. *The Portraits of John Marshall.* Charlottesville: University Press of Virginia, 1977.

Tuckerman, Henry T. "Frazee." *Book of the Artists: American Artist Life*, 572–573. New York: G. P. Putnam & Son, 1867.

Voss, Frederick S. *John Frazee, 1790–1852, Sculptor.* Washington, D.C., and Boston: The National Portrait Gallery and The Boston Athenaeum, 1986.

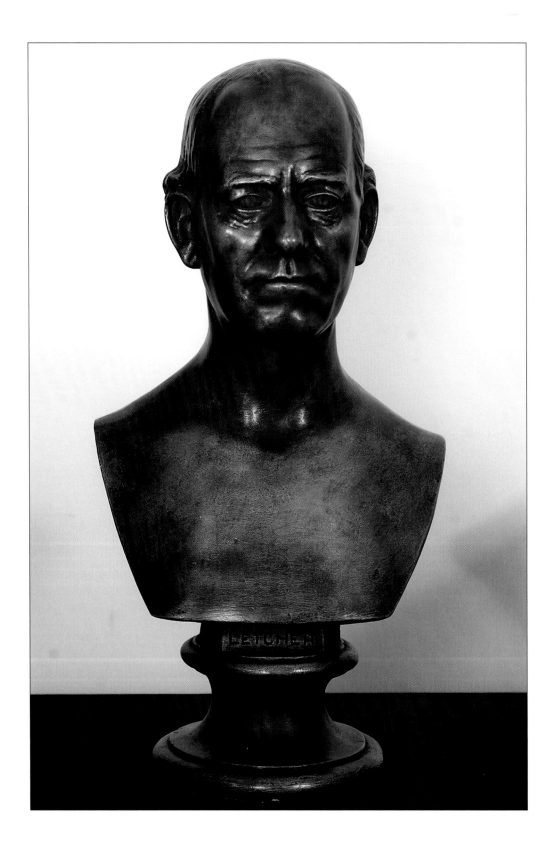

ALEXANDER GALT (1827–1863)
JOHN LETCHER (1813–1884)

1862
Painted plaster
Height 24¼ inches
Inscribed on back at lower center "A. GALT. Sc."
Inscribed on front "LETCHER"
Collection of the Library of Virginia

Born in Norfolk, Virginia, on 26 June 1827, Alexander Galt became a leading southern sculptor. He showed artistic talent while he was a schoolboy and made his first attempts at sculpting by using chalk to form miniature figures. He also made pencil and crayon portraits and worked with alabaster and conch shells to make cameos. Though not wealthy, his family had enough resources for Galt to enjoy frequent opportunities to travel, allowing him to see important works of art in Philadelphia and Washington, D.C. Before he was twenty years old, his family decided that Galt should study in Italy, a common goal for aspiring sculptors of the age. A friend and supporter arranged for free passage, and Galt's father provided financial support.[1]

Galt arrived in Florence in January 1849 and studied ancient art, took drawing classes, and befriended established artists such as Horatio Greenough and Joel Tanner Hart. Galt developed a neoclassical style, sculpting portrait busts and idealized figures. His female allegorical bust entitled *Virginia*, which sold for $250 in 1851 at the American Art-Union in New York, surely provided encouragement to the young sculptor. Galt remained in Italy for much of the next decade but from the autumn of 1853 to the summer of 1856 he operated a successful studio in Richmond where he executed works for prominent Virginia families. In 1854 he received an important commission from the Commonwealth of Virginia to model a life-size figure of Thomas Jefferson, which was installed in the Rotunda at the University of Virginia in 1861. After a second period of work in Italy, Galt returned to Virginia in 1860 and opened a sculpture studio in Richmond. The Civil War frustrated the promising career that Galt had begun, and he had trouble making ends meet. After the Virginia militia took over Norfolk, Galt prepared maps and plans and conducted surveying for defenses. He modeled busts of Confederate president Jefferson Davis and Virginia governor John Letcher, hoping to return to Italy later and carve them in marble.[2]

Galt's health was poor during 1862. He wrote in his diary entry for 13 July: "I have not done any work lately. I go to the State Library every day and read and then after dinner take a nap. I am so weak that I can't take much exercise." He complained about the shortage of basic necessities such as clothes and food and was disappointed in the market for his art. On 21 December Galt wrote that "the likeness of Davis did not pay my expenses—nor Letcher's either." Perhaps as a consequence of executing the bust of the governor, Galt received an appointment on 11 October 1862 as an aide-de-camp to Letcher. He earned no salary but hoped to continue some work on his art. In December, while visiting the camp of Lieutenant General Thomas J. "Stonewall" Jackson to make studies for a portrait, Galt evidently contracted smallpox. Alexander Galt died in Richmond on 19 January 1863. A year later in 1864 a fire destroyed the warehouse that contained much of the art from his fifteen-year career.[3]

John Letcher was born in Lexington on 29 March 1813. He attended Washington College, now Washington and Lee University, and in 1839 was admitted to the bar and began to practice law in Lexington. He also edited a newspaper, the *Valley Star*, from 1840 to 1850. Letcher was a member of the Convention of 1850–1851 that revised the state constitution, which included some, but not all, of the democratic reforms that he and other members from the western counties supported. A Democrat, Letcher was a member of the United States House of Representatives from 1851 until 1859. He took office as the governor of Virginia on 1 January 1860. Opposed to secession until the Virginia Convention of 1861 submitted an ordinance of secession to a popular referendum in April 1861, Letcher threw himself fully into the effort to defend Virginia. By the time Letcher's term as governor concluded on 1 January 1864, he was so unpopular because of his support for the Davis administration that he could not win a seat in the Confederate Congress. He

returned to his law practice in Lexington but after the war was briefly jailed and charged with treason. He was not tried, and President Andrew Johnson pardoned him in 1867. Letcher was a member of the board of visitors of the Virginia Military Institute from 1866 to 1880, served in the Virginia House of Delegates from 1875 to 1877, and continued to practice law in Lexington until his death on 26 January 1884.[4]

It was as a still-popular war governor that Letcher sat for Galt in June 1862. The bust is a good likeness, but the overall effect is rather serious. It is not clear whether this was the result of Letcher's personality or Galt's distress over his own personal situation. After completing the work on the bust of Letcher, Galt wrote that he had five or six orders for plaster copies at $20 each, but sales were poor, perhaps because Letcher was becoming increasingly unpopular. Only one other copy, now in the collection of the Virginia Military Institute, is known to exist. The provenance of the Library of Virginia's plaster bust of John Letcher is not known, but it was listed in the Library's first inventory of its art collection, published in 1906.[5]

TLK

◆

NOTES

1. Betsy Fahlman, *Spirit of the South: The Sculpture of Alexander Galt, 1827–1863* (Williamsburg: The College of William and Mary, Joseph and Margaret Muscarelle Museum of Art, 1992), 5, 6–9.

2. Ibid., 13–14, 16–17, 49, 52–53; Wayne Craven, *Sculpture in America* (New York: Thomas Y. Crowell Company, 1968), 205. Copies of the Jefferson Davis bust are in the Museum of the Confederacy in Richmond and in the Department of Archives and History in Montgomery, Alabama.

3. Fahlman, *Spirit of the South*, 55 (quoting diary) (1st quotation), 56; Alexander Galt to James Dickie Galt, 21 December 1862 (2d quotation), Gault Family Papers,

1847–1941, MS 78.3, Special Collections, Earl Gregg Swem Library, College of William and Mary, Williamsburg, Va.

4. F. N. Boney, "Letcher, John," *American National Biography* (New York and Oxford, Eng.: Oxford University Press, 1999), 13:526–528.

5. Galt to William Richard Galt, 6 October 1862, Gault Family Papers, Swem Library, College of William and Mary; *Third Annual Report of the Library Board of the Virginia State Library, 1905–1906, To Which is Appended the Third Annual Report of the State Librarian* (Richmond: Davis Bottom: Superintendent of Public Printing, 1906), 39.

REFERENCES

Boney, F. N. *John Letcher of Virginia: The Story of Virginia's Civil War Governor*. University, Ala.: University of Alabama Press, 1966.

————. "Letcher, John." *American National Biography*, 13:526–528. New York and Oxford, Eng.: Oxford University Press, 1999.

Craven, Wayne. *Sculpture in America*. New York: Thomas Y. Crowell Company, 1968.

Fahlman, Betsy. *Spirit of the South: The Sculpture of Alexander Galt, 1827–1863*. Williamsburg: The College of William and Mary, Joseph and Margaret Muscarelle Museum of Art, 1992.

ATTRIBUTED TO MARCUS GHEERAERTS THE YOUNGER (1561 OR 1562–1635) PORTRAIT OF A LADY, CALLED QUEEN ELIZABETH I (1533–1603)

Ca. 1595–1600
Oil on wood panel
44 ½ x 34 ¼ inches
Collection of the Commonwealth of Virginia, gift of Waldorf and Nancy Langhorne Shaw Astor, Viscount and Viscountess Astor

Marcus Gheeraerts the Younger was born in Brugge, Flanders, about 1561 or 1562 and was the son of Marcus Gheeraerts the Elder, also an artist. To escape religious persecution, the father took his son to England in 1568. The younger Gheeraerts lived most of his life in London and probably learned painting from his father, becoming the most popular portraitist in England by the 1590s, painting English ladies and gentlemen and members of court. Queen Elizabeth I sat for Gheeraerts the Younger about 1592. His most famous portrait of the queen, known as the Ditchley portrait (ca. 1592), is in the collection of the National Portrait Gallery in London. Marcus Gheeraerts the Younger died in London on 19 January 1636.[1]

BEFORE CONSERVATION, MAY 1999

Elizabeth I, only child of Henry VIII and Anne Boleyn, was born at Greenwich Palace, Kent County, England, on 7 September 1533. She succeeded her half-sister Mary as queen on 17 November 1558 and reigned for almost forty-five years, during which time the arts and literature flourished, her fleets defeated the Spanish Armada, and English colonists made their first attempts to settle permanently in North America. Elizabeth never married and was known as the Virgin Queen—thus the origin of the colony's name of *Virginia*. Queen Elizabeth died at her court on 24 March 1603.[2]

In December 1926, Governor Harry Flood Byrd accepted a surprise Christmas present on behalf of the Commonwealth of Virginia, a large oil portrait of Queen Elizabeth I, from Lord and Lady Astor. Nancy Astor, born Nancy Witcher Langhorne, a native of Virginia, added a personal note explaining the gift: "Tradition plays so large a part in the life of all Virginians, that I feel it will help the women of Virginia to be reminded of Queen Elizabeth who always put her country first, and proved by her courage and ability that women can add to a country's greatness, even if they don't happen to be mothers!!"[3]

The portrait has been on display in the Executive Mansion or in the Capitol since 1926. Research has so far yielded no information about the provenance of the painting or when the Astors acquired it. Between 1999 and 2001, the painting underwent a major conservation treatment. The conservation work revealed that the original painting had been hidden during several repainting campaigns and that it was a very different painting underneath, dating to the late sixteenth century. At least three or four times, beginning early in the eighteenth century, the original had been changed in many details, with only the subject's face and neck remaining largely unaltered. The changes resulted from retouching damaged sections or perhaps resulted from making alterations to the portrait so that it would look like other, well-known portraits of the queen. Conservators removed almost all of the overpaint and returned the portrait to its original appearance.[4]

The result is an exquisite and unusual painting, surely the work of a skilled artist. Removal of a later

CONSERVATION REVEALED THAT THE RIGHT HAND HAD BEEN REPOSITIONED (*left*) FROM ITS ORIGINAL LOCATION (*right*) AND THAT THE STOMACHER AND THE NECKLACE HAD BEEN CONSIDERABLY SHORTENED.

flowered background revealed a tree, probably a juniper, and a building set into a landscape in the distance. The identity of that building is not known, and some of its details are obscured by damage. The ultimate key to unlocking some of the mysteries of the painting may be the identification of the building, which might have been a place of importance to the sitter or the painting's owner. As a result of the conservation treatment, we can now date the costume and hairstyle in the portrait to the period between 1595 and 1600. The treatment, however, raised questions about whether the painting's subject is, indeed, Elizabeth I. The uniqueness of this image works against an identification of the sitter as Elizabeth, as most portraits of her were copied after recognized patterns. If the portrait was not intended to represent the queen, it is probably of an unmarried lady in her court. The most striking potential clue to the sitter's identity in Virginia's portrait became apparent with infrared photography that revealed changes to the sitter's face made by the artist. Elizabeth is known to have had a pronounced crook in her nose. The subject of

Virginia's portrait had a similar nose in the original sketch on the panel, but the artist straightened her nose when painting the portrait.[5]

The attribution to Marcus Gheeraerts the Younger was made possible only after the conservation treatment, extensive research, and consultation. The portrait has features resembling others by this artist, such as round eyelids, the handling of the lips, fragile and translucent skin, and the modeling of the hands. Significantly, the artist painted some of the earliest portraits in outdoor settings, which was unusual until the seventeenth century.

TLK

NOTES

1. Roy Strong, *The English Icon: Elizabethan and Jacobean Portraiture* (New York: The Paul Mellon Foundation for British Art in Association with Pantheon Books, 1969), 22–23, 289. See also Karen Hearn and Rica Jones, *Marcus Gheeraerts II, Elizabethan Artist* (London: Tate Publications, 2002).

2. Patrick Collinson, "Elizabeth I," *Oxford Dictionary of National Biography* (New York and Oxford, Eng.: Oxford University Press, 2004), 18:95–130.

3. Lady Astor to Governor Byrd, 13 December 1926, Accession 29523, in Virginia, Governor (1926–1930: Byrd), Executive Papers, 1926–1930, Accession 22561, State Government Records Collection, The Library of Virginia, Richmond.

4. For more information on the conservation, see Tracy L. Kamerer, "The Restoration of a Monarch: Virginia's Portrait of Queen Elizabeth I," *Virginia Cavalcade* 51 (2002): 72–75.

5. Elizabeth's advanced age in the 1590s would have made little difference in her appearance in portraits, as artists, such as Nicholas Hilliard, sought to flatter her by making her appear younger. See Roy Strong, *Artists of the Tudor Court: The Portrait Miniature Rediscovered, 1520–1620* (London: The Victoria and Albert Museum, 1983), 126–127.

REFERENCES

Lady Astor to Governor Byrd, 13 December 1926, Accession 29523. In Virginia. Governor (1926–1930: Byrd), Executive Papers, 1926–1930. Accession 22561, State Government Records Collection, The Library of Virginia, Richmond.

Hearn, Karen, and Rica Jones. *Marcus Gheeraerts II, Elizabethan Artist*. London: Tate Publications, 2002.

Kamerer, Tracy L. "The Restoration of a Monarch: Virginia's Portrait of Queen Elizabeth I." *Virginia Cavalcade* 51 (2002): 72–75.

Strong, Roy. *The English Icon: Elizabethan and Jacobean Portraiture*. New York: The Paul Mellon Foundation for British Art in Association with Pantheon Books, 1969.

_____. *The Tudor and Stuart Monarchy: Pageantry, Painting, Iconography*, vol. 2, *Elizabethan*. Rochester, N.Y.: The Boydell Press, 1995.

LOUIS MATHIEU DIDIER GUILLAUME (1816–1892)
WYNDHAM ROBERTSON (1803–1888)

Ca. 1880
Oil on canvas
30 inches x 25 inches
Inscribed at lower left "L. M. D. Guillaume"
Collection of the Library of Virginia, gift of Wyndham Robertson

Louis Mathieu Didier Guillaume enjoyed a long career as a portrait painter in the American South. Born in Nantes, France, on 19 June 1816, he studied with the younger Pierre Lacour, of Bordeaux, and at the École des Beaux-Arts, in Paris, with Paul Delaroche, from whom he absorbed a reliance on line and detail. Guillaume exhibited a self-portrait at the 1837 Paris Salon, a historical painting of the martyrdom of Saint Benjamin in 1848, and the head of a girl in 1852. In 1848 he won a competition to paint the figure of Liberté in the city hall in Bordeaux. Early in the 1850s, William Cabell Rives, the American minister to France, persuaded Guillaume, who had drawn the Rives children in pastels in Paris, to relocate to the United States. In 1853, Rives commissioned a copy of the Amedée Van Loo portrait of Benjamin Franklin for the Virginia Historical Society. Guillaume exhibited his head of a girl and two other portraits at the National Academy of Design in New York City in 1855 and in August 1856 accepted a commission to paint the champion horse, Emperor, at the Rives family residence, Castle Hill, in Albemarle County. He also painted portraits, including members of the Rives and Randolph families, charging $50 to $150 depending on the size of the figure.[1]

Guillaume and his family resided in Richmond from about 1857 to 1870. There, Guillaume painted portraits of landowners and merchants, and during the Civil War soldiers and government officials as well. In March 1866 Guillaume and Michael Knoedler, a German entrepreneur and publisher of American art, entered into an agreement to produce equestrian portraits of Robert E. Lee, Thomas J. "Stonewall" Jackson, Pierre Gustave Toutant Beauregard, Jefferson Davis, and John Singleton Mosby. Guillaume agreed to paint the portraits for $2,000 and a 20 percent royalty on the engraved mezzotints that Knoedler sold. Guillaume later painted a sixth portrait, of Joseph Eggleston Johnston, but of the set only the paintings of Lee and Jackson were engraved.[2]

In 1869, Guillaume applied for the post of director of the gallery that William Wilson Corcoran had just established in Washington, D.C. In his letter of application, Guillaume outlined his studies under Lacour and Delaroche and wrote that he possessed "the necessary experience for the thorough organization and administration of the above named Gallery and of an Academy of Design & Painting [for the] furtherance of Art should any be organized." Although he did not receive the appointment, Guillaume moved to Washington in 1870 or 1871 and executed a number of canvases for Corcoran, including landscapes and still lifes, and he also repaired and restored several works in Corcoran's collection. Louis Mathieu Didier Guillaume died at his home in Washington, D.C., on 13 April 1892. The *Washington Post* eulogized him on 17 April as a "genuine poet in painting, many of his pictures being perfect gems." He was buried at Oak Hill Cemetery in Washington, D.C., which had been established by Corcoran. On his easel at the time of his death was his last work, a historical rendering of the 1836 Battle of San Jacinto, during the Texas Revolution.[3]

Guillaume's portrait of Wyndham Robertson, painted in 1880, demonstrates the artist's attention to detail in creating a precise likeness of the sitter. Guillaume may have used photographs to complete the portrait. The painting shows Robertson seated at his desk, with the 1859 nine-sheet edition of the map of Virginia, revised by Lewis von Buchholtz, hanging on the wall. The atmosphere is of utter calm and studiousness.[4]

Born on 26 January 1803 near Manchester, Virginia, Wyndham Robertson studied at the College of William and Mary and was admitted to the bar in 1824. He was elected to the Council of State in 1830 and reelected in 1833. When Governor Littleton Waller Tazewell resigned in March 1836, Robertson became acting governor, serving until March 1837, when David Campbell took office. Robertson served in the House of

Delegates from 1837 to 1841 and again from 1859 to 1865. A Unionist at the time of the secession crisis, he introduced an anticoercion resolution stating that Virginia would fight with other Southern states if invaded. In August 1860, Robertson published an article on Pocahontas's marriage in the *Southern Literary Messenger*. The article was republished in book form in 1887. Retiring from political life in 1865, Robertson moved to Abingdon, where he died on 11 February 1888.[5]

Wyndham Robertson gave the portrait to the State Library in 1881.[6]

BCB

NOTES

1. Annabel Shanklin Perlik, "Signed 'L. M. D. Guillaume': Louis Mathieu Didier Guillaume, 1816–1892" (Master of Arts thesis, The George Washington University, 1979), 9, 151.

2. Ibid., 156–157; Harold Holzer and Mark E. Neely Jr., " 'In the Best Possible Manner': The Equestrian Portraits of L. M. D. Guillaume," *Virginia Cavalcade* 43 (1993): 86–95.

3. Perlik, "Signed 'L. M. D. Guillaume,' " quoting letter of application on 159 (1st quotation); "Death of a Noted Painter," *Washington Post*, 17 April 1892, p. 2 (2d quotation).

4. By the mid-nineteenth century, not all portraits were taken from life. The introduction of photography allowed an artist or sculptor to create a portrait without lengthy sessions with the subject sitting for the artist.

5. "Robertson, Wyndham," *National Cyclopaedia of American Biography* (New York: James T. White & Company, 1907), 5:449.

6. "Report of the Joint Committee on the Library to the General Assembly," *Journal of the Senate of the Commonwealth of Virginia, Begun . . . March 7, 1882, . . . Extra Session*, Senate Doc. No. 1 (Richmond: R. F. Walker, Superintendent Public Printing, 1882), 3.

REFERENCES

Holzer, Harold, and Mark E. Neely Jr. " 'In the Best Possible Manner': The Equestrian Portraits of L. M. D. Guillaume." *Virginia Cavalcade* 43 (1993): 86–95.

Mundy, Robyn. "Wyndham Robertson." *The Historical Society of Washington County, Va. Bulletin*, ser. II, no. 33 (1996): 45–73.

Perlik, Annabel Shanklin. "Signed 'L. M. D. Guillaume': Louis Mathieu Didier Guillaume, 1816–1892." Master of Arts thesis, The George Washington University, 1979.

"Robertson, Wyndham." *National Cyclopaedia of American Biography*, 5:449. New York: James T. White & Company, 1907.

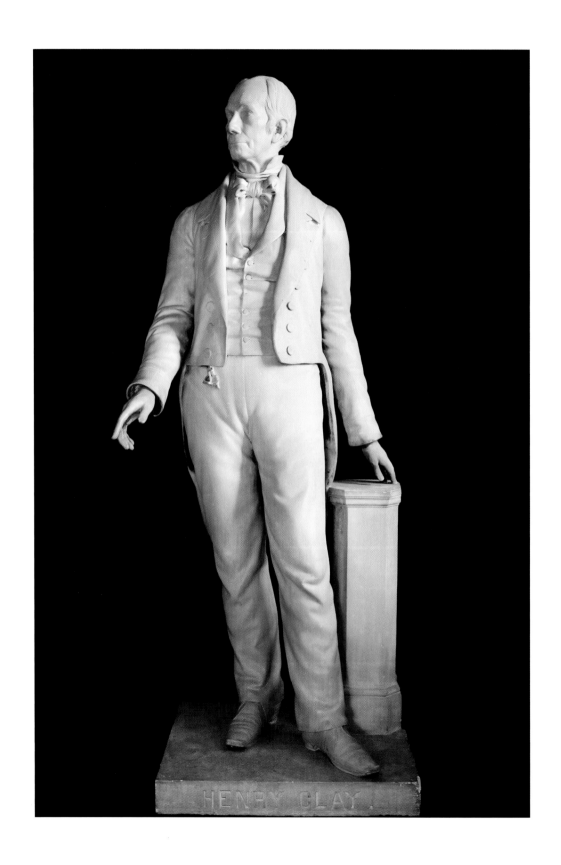

JOEL TANNER HART (1810–1877)
HENRY CLAY (1777–1852)

1847; completed in 1859

Marble

Height 77¼ inches

Inscription: on front of base "HENRY CLAY"; on back of base at lower left "J. T. Hart. Sculpt.ʳ· 1847."

Collection of the Commonwealth of Virginia, gift of the Virginia Association of Ladies for Erecting a Statue to Henry Clay

Born in Clark County, Kentucky, on 11 February 1810, Joel Tanner Hart had little formal education and worked as a stonemason and monument cutter before mastering the craft of sculpture. By 1835 he had moved to Lexington, Kentucky, where he worked in a marble yard carving tombstones. There he attracted the attention of Cassius Marcellus Clay, a journalist and abolitionist. Hart carved a bust of Clay that impressed Shobal V. Clevenger, a sculptor from Cincinnati. Not long afterward, Hart joined Clevenger in Cincinnati to study and to carve reliefs. Hart established a studio in Lexington in 1837 and, to improve his technique, studied anatomy at Transylvania College. He produced portrait busts of prominent Kentucky educators, politicians, and merchants, and in 1838 he sculpted a portrait bust of Andrew Jackson. Hart exhibited busts of Cassius Clay and Clay's distant kinsman Henry Clay at the Artists' Fund Society, in Philadelphia, in 1845, and a portrait bust of an unnamed lady at the Pennsylvania Academy of the Fine Arts in 1861.[1]

In August 1845, Hart embarked on a promotional tour of the major eastern cities, beginning in Richmond. Carrying with him his busts of Cassius and Henry Clay, he met with the Virginia Association of Ladies for Erecting a Statue to Henry Clay and received the commission to make a monumental marble statue of the Virginia-born Kentucky statesman. Hart also visited Washington, D.C., Baltimore, Philadelphia, and New York. He received orders for plaster casts of his portrait busts and met with leading artists, including Thomas Sully, John Neagle, and Asher B. Durand. In 1849, having modeled the Clay statue in plaster in 1847, Hart left for Europe, intending to oversee production of the statue in marble. Distracted by other projects and settling into life in the American art colony in Florence, Italy, Hart did not complete the statue until 1859, much to the consternation of the Ladies' Association.[2]

Hart was active in the Florence group of artists that included Hiram Powers, Chauncey Bradley Ives, Randolph Rogers, and William Henry Rinehart. His studio in the Piazza della Indipendenza was a popular stop for visiting American tourists. Hart devised and patented a pointing machine to enable sculptors to transfer accurate measurements of the human face directly to the clay model. The machine never gained acceptance from other sculptors who found the device too complicated for practical use. Hart was a capable portraitist but also sculpted several ideal subjects, including *Il Penserosa*, *Morning Glory*, and *Woman Triumphant*, an idealized figure he began planning in the 1850s. Soon after completing the model for *Woman Triumphant*, which he considered his masterpiece and on which he had worked for more than ten years, Joel Tanner Hart died in Florence, Italy, on 2 March 1877. On 18 June 1887, his remains were reinterred in Frankfort, Kentucky.[3]

Henry Clay was born on 12 April 1777 in Hanover County, Virginia, and worked as a clerk in the chancery court in Richmond, where he attracted the attention of Chancellor George Wythe. Clay quickly became Wythe's secretary and law student. Admitted to the bar in Virginia in 1797, Clay soon moved to Lexington, Kentucky, and began his political career by winning election to the lower house of the Kentucky legislature in 1803. He completed two unexpired terms in the United States Senate (from November 1806 to March 1807, and from January 1810 to March 1811), was Speaker of the Kentucky House of Representatives in 1808, and then won election to the United States House of Representatives. Clay was Speaker of the House for ten years beginning in November 1811. He advocated war against Great Britain in 1812 and was one of the commissioners President James Madison

appointed in 1814 to negotiate an end to the war. An unsuccessful candidate for president in 1824, Clay served as secretary of state from 1825 to 1829, and during the presidency of Andrew Jackson led the opposition that coalesced into the Whig Party. Clay was elected to the U.S. Senate in 1831 and served until 1842. He ran unsuccessfully for president in 1832 and again in 1844. Clay returned to the Senate in 1849 and served until six months before his death in June 1852. Known as the Great Compromiser, Clay was the key person in negotiating the Missouri Compromise of 1820 to maintain the political balance between slave and free states, and in 1850 he was one of the leading advocates of the compromise that in that year averted another possible breakup of the Union. Henry Clay died of tuberculosis on 29 June 1852 and was the first American statesman to lie in state in the U.S. Capitol Rotunda.[4]

The Virginia Association of Ladies for Erecting a Statue to Henry Clay was formed in December 1844 to honor the Virginia-born politician and leader of the Whig party. Led by Lucy Maria Johnson Barbour, widow of James Barbour, a former governor of Virginia and U.S. senator, the association met with Hart in September 1845 and commissioned him to create a marble statue of Clay for $5,000. Hart visited Clay's home in Kentucky and took measurements of Clay's head and body. He also had daguerreotypes made of Clay from different angles. Using these resources, Hart designed the statue to show Clay as if in debate. The orator stands with his left fingers touching a pedestal and his right hand extended outward. Lorado Taft, in his *History of American Sculpture* (1903), noted that Hart's lack of training early in his career hampered the artist's ability to sculpt the human body convincingly. Taft criticized the Clay statue as having "a look of preternatural gravity coupled with unstable equilibrium," but he remarked that Clay's "admirably ugly head" was "modelled with great sincerity and well carved; likewise it is full of life."[5]

The project dragged on as a series of delays and misfortunes plagued Hart and the statue. The first plaster model of the statue was lost at sea, and a second model did not arrive in Florence until a year later. Hart finally completed the marble statue and early in 1859 had it shipped to Richmond, where it was placed in the western portion of Capitol Square. It was dedicated on Clay's birthday, 12 April 1860, with great fanfare, including a dedicatory address by Benjamin Johnson Barbour, son of Lucy Barbour. Its protective canopy, a cast-iron gazebo, was constructed after the dedication. Little more than a year later, the *Richmond Dispatch* noted that the statue "has been lately subjected to so much handling by visitors that the marble has become much discolored." In 1862 the *Richmond Whig* complained that "it seems to be nobody's business to give attention to the statue of Henry Clay." In following years, Richmond newspapers reported that two fingers had been broken off by "wicked boys" who made the Clay and Washington statues targets for rock throwing. Finally, in 1930, the gazebo, which had become unstable, was razed and the statue of Henry Clay was moved into the old chamber of the House of Delegates in the Capitol.[6]

BCB

NOTES

1. David B. Dearinger, "Joel Tanner Hart: Kentucky's Neo-Classic Sculptor," *Kentucky Review* 8 (Spring 1988): 3–32.

2. David B. Dearinger, ed., "The Diary of Joel Tanner Hart, Kentucky Sculptor," *Filson Club History Quarterly* 64 (1990): 5–31. The date "1847" on the finished marble is the year Hart modeled the statue, not the year the marble was cut.

3. Clifford Amyx, "Joel T. Hart's Executors: George Saul and Edward Silsbee," *Filson Club History Quarterly* 65 (1991): 474–486; Dearinger, "Joel Tanner Hart: Kentucky's Neo-Classic Sculptor," 3–32; J. Winston Coleman Jr., *Three Kentucky Artists: Hart, Price, Troye* (Lexington: University Press of Kentucky, 1974), 16.

4. Robert V. Remini, "Clay, Henry," *American National Biography* (New York and Oxford, Eng.: Oxford University Press, 1999), 5:24–28.

5. Dearinger, "The Diary of Joel Tanner Hart," 22; Elizabeth R. Varon, "'The Ladies are Whigs': Lucy Barbour, Henry Clay, and Nineteenth-Century Virginia Politics," *Virginia Cavalcade* 42 (1992): 72–83; Lorado Taft, *The History of American Sculpture* (New York: The Macmillan Company, 1903), 101–102 (quotations).

6. *Richmond Dispatch*, 22 June 1861, p. 2 (1st quotation); *Richmond Daily Whig*, 13 April 1860, p. 2 (2d quotation); *Richmond Whig*, 30 May 1862, p. 2; "The Clay Statue," *Richmond Sentinel*, 22 April 1863, p. 2 (3d quotation), and "Throwing Stones," 24 June 1864, p. 1; W. Harrison Daniel, "Richmond's Memorial to Henry Clay: The Whig Women of Virginia and the Clay Statue," *Richmond Quarterly* 8 (Spring 1986): 42. In addition to the marble statue, Hart cast a bronze copy for the city of New Orleans and attended its unveiling on 12 April 1860, the same day the Richmond statue was dedicated. The city of Louisville, Kentucky, later also ordered a marble replica of the Clay statue, which was unveiled in the courthouse in 1867. David B. Dearinger, "Hart, Joel Tanner," *American National Biography* (New York and Oxford, Eng.: Oxford University Press, 1999), 10:238.

REFERENCES

Amyx, Clifford. "Joel T. Hart's Executors: George Saul and Edward Silsbee." *Filson Club History Quarterly* 65 (1991): 474–486.

Coleman, J. Winston, Jr. *Three Kentucky Artists: Hart, Price, Troye.* Lexington: University Press of Kentucky, 1974.

Daniel, W. Harrison. "Richmond's Memorial to Henry Clay: The Whig Women of Virginia and the Clay Statue." *Richmond Quarterly* 8 (Spring 1986): 39–43.

Dearinger, David B. "The Diary of Joel Tanner Hart, Kentucky Sculptor." *Filson Club History Quarterly* 64 (1990): 5–31.

_____. "Hart, Joel Tanner." *American National Biography*, 10:237–239. New York and Oxford, Eng.: Oxford University Press, 1999.

_____. "Joel Tanner Hart: Kentucky's Neo-Classic Sculptor." *Kentucky Review* 8 (Spring 1988): 3–32.

Remini, Robert V. "Clay, Henry," *American National Biography*, 5:24–28. New York and Oxford, Eng.: Oxford University Press, 1999.

_____. *Henry Clay: Statesman for the Union.* New York: W. W. Norton, 1991.

Varon, Elizabeth R. "'The Ladies are Whigs': Lucy Barbour, Henry Clay, and Nineteenth-Century Virginia Politics." *Virginia Cavalcade* 42 (1992): 72–83.

_____. *We Mean to Be Counted: White Women & Politics in Antebellum Virginia.* Chapel Hill: University of North Carolina Press, 1998.

HENRY CLAY, CAPITOL SQUARE, CA. 1890S

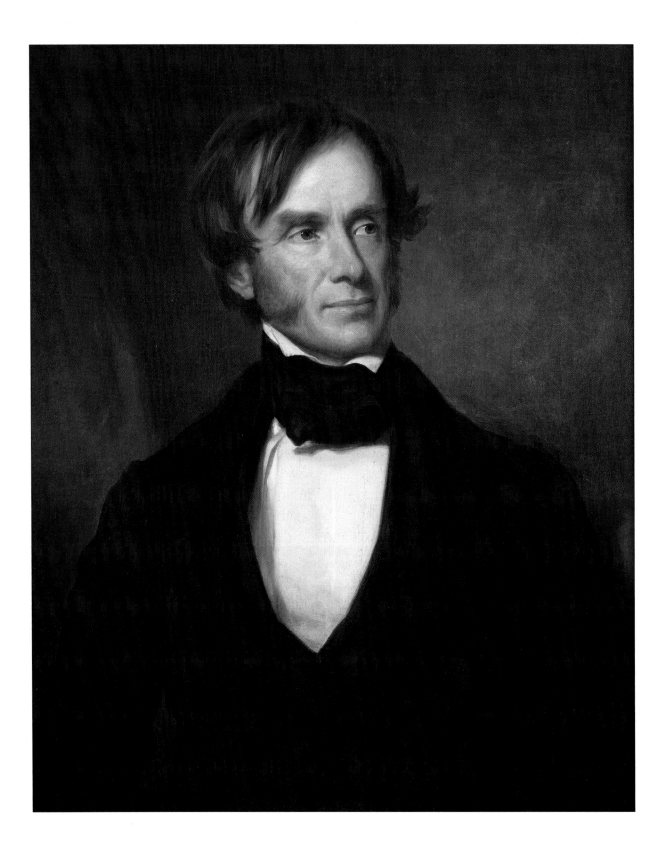

GEORGE PETER ALEXANDER HEALY (1813–1894)
WILLIAM SEGAR ARCHER (1789–1855)

1846
Oil on canvas
30 inches x 25⅛ inches
Collection of the Library of Virginia, gift of Martha J. Archer

One of the most renowned and prolific nineteenth-century American artists, George Peter Alexander Healy was born in Boston on 15 July 1813. He was largely self-trained when, with encouragement from painter Thomas Sully, he opened a portrait studio in Boston at age eighteen. Healy exhibited for the first time at the Boston Athenaeum early in the 1830s. Sully encouraged him to study in Europe, and in 1834 Healy went to France, where he studied with the painter Antoine-Jean Gros, a student of Jacques-Louis David, and copied paintings at the Louvre. He learned quickly, still mostly on his own, and exhibited at the Paris Salon many times between 1836 and 1890. Healy won a medal in 1840, which led to an invitation to meet King Louis-Philippe, who gave him several royal commissions during the next decade.[1]

After visiting Italy, Healy in 1836 moved to London, where he attended classes at the Royal Academy and opened a studio. During the next six years he painted portraits of leading members of British society and one of Queen Victoria. He was soon in demand by prominent European aristocrats and royal personages. Healy returned to the United States in 1842, his reputation having preceded him, to execute a series of portraits of presidents and politicians of the United States for the museum at Versailles on commission from King Louis-Philippe. He painted several portraits before the king went into exile at the time of the Revolution of 1848. Healy worked for more than a decade on the East Coast before establishing a residence in Chicago in November 1856. After the Civil War he moved to Italy and later to Paris. In 1892 Healy returned to the United States, his health failing, and died in Chicago on 24 June 1894.[2]

Healy painted the portrait of Virginia's United States senator William Segar Archer probably while in Washington, D.C. Born in Amelia County, Virginia, on 5 March 1789, William Segar Archer studied law at the College of William and Mary, was admitted to the bar in 1810, and practiced in Amelia County. He represented the county in the House of Delegates from 1812 to 1814 and again from 1818 to 1819 and served in the United States House of Representatives from 1820 until 1835, when he was defeated for reelection. Elected to the United States Senate in 1841, Archer served one six-year term. He was a states' rights Whig, more closely aligned with his friend President John Tyler than with Henry Clay and the national leadership of the Whig Party. Archer was an unsuccessful candidate for the state constitutional conventions that met in 1829 and 1850. He never married and died at his home in Amelia County on 28 March 1855.[3]

Healy's portrait of Archer blends eighteenth-century classical portraiture, with its plain, flat background, and the contemporary, romantic style of soft, gestural brushstrokes and liberal use of color. Healy described Archer as "tall, dark, refined in appearance and manner," and painted him accordingly. Created at the height of Healy's technical skill, the portrait exhibits his suave technique and ability to capture skillfully the individuality of his sitters. *William Segar Archer* is a classic example of the polished portraits that Healy's style-conscious patrons desired.[4]

In 1881 Archer's surviving sister and heir, Martha J. Archer, presented the portrait to the State Library.[5]

TLK

NOTES

1. George P. A. Healy, *Reminiscences of a Portrait Painter* (Chicago: A. C. McClurg and Company, 1894), 27; John

Caldwell and Oswaldo Rodriguez Roque, with Dale T. Johnson, *American Paintings in the Metropolitan Museum of Art*, vol. 1, *A Catalogue of Works by Artists Born by 1815*, ed. Kathleen Luhrs (New York: The Metropolitan Museum of Art in Association with Princeton University Press, 1980), 569.

2. Caldwell et al., *American Paintings in the Metropolitan Museum of Art*, 1:569; Lois Marie Fink, "Healy, George Peter Alexander," *American National Biography* (New York and Oxford, Eng.: Oxford University Press, 1999), 10:454–456; Healy, *Reminiscences of a Portrait Painter*, especially 67.

3. Brent Tarter, "Archer, William Segar," *Dictionary of Virginia Biography* (Richmond: The Library of Virginia, 1998), 1:195–196.

4. Healy quoted in Virginia Museum of Fine Arts, *A Souvenir of the Exhibition Entitled Healy's Sitters, or, A Portrait Panorama of the Victorian Age* (Richmond: The Virginia Museum of Fine Arts, 1950), 26.

5. See the correspondence between Martha J. Archer and Governor Frederick W. M. Holliday in Senate Doc. No. 2, *Journal of the Senate of the Commonwealth of Virginia . . . 1881* (Richmond: R. F. Walker, Superintendent Public Printing, 1881), 6–7.

Fink, Lois Marie. "Healy, George Peter Alexander." *American National Biography*, 10:454–456. New York and Oxford, Eng.: Oxford University Press, 1999.

Healy, George P. A. *Reminiscences of a Portrait Painter*. Chicago: A. C. McClurg and Company, 1894.

Tarter, Brent. "Archer, William Segar." *Dictionary of Virginia Biography*, 1:195–196. Richmond: The Library of Virginia, 1998.

Virginia Museum of Fine Arts. *A Souvenir of the Exhibition Entitled Healy's Sitters, or, A Portrait Panorama of the Victorian Age*. Richmond: The Virginia Museum of Fine Arts, 1950.

REFERENCES

Caldwell, John, and Oswaldo Rodriguez Roque, with Dale T. Johnson. *American Paintings in the Metropolitan Museum of Art*, vol. 1, *A Catalogue of Works by Artists Born by 1815*. Edited by Kathleen Luhrs, 569–576. New York: The Metropolitan Museum of Art in Association with Princeton University Press, 1980.

De Mare, Marie. *G. P. A. Healy, American Artist: An Intimate Chronicle of the Nineteenth Century*. New York: David McKay Company, Inc., 1954.

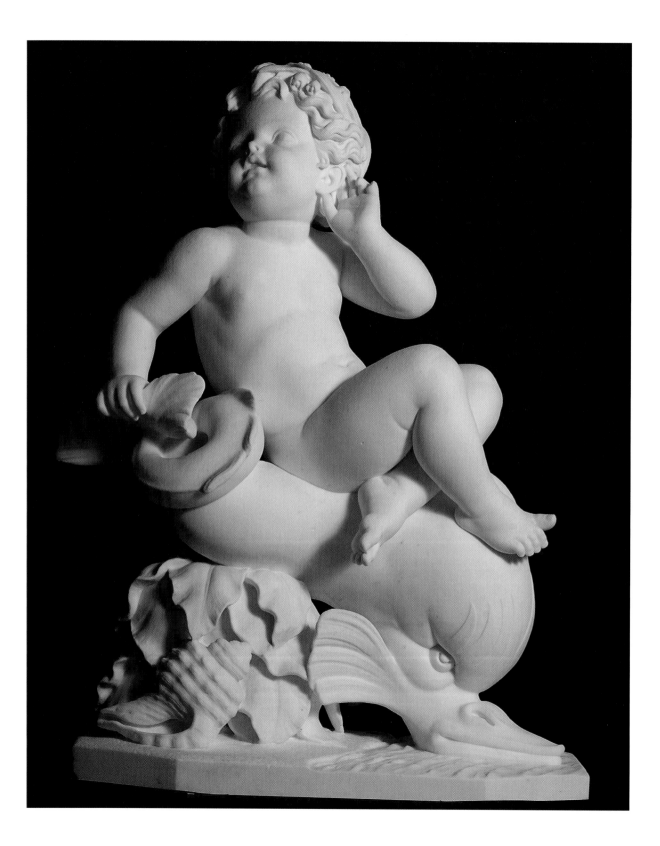

HARRIET GOODHUE HOSMER (1830–1908)
CUPID ON DOLPHIN

Ca. 1861
Marble
Height approximately 33½ inches
Inscribed on back of base "HARRIET HOSMER
FECIT ROMÆ"
Collection of the Executive Mansion, gift of Marion
Elizabeth Moncure (Mrs. Robert Vernon Harris) Duncan

Encouraged as a young girl to be active, self-sufficient, and career-minded, Harriet Goodhue Hosmer was one of the earliest women sculptors in the United States. She was born in Watertown, Massachusetts, on 9 October 1830. Her mother, a sister, and two brothers all died of tuberculosis when she was very young, and her father, a physician, concerned about her health, advocated exercise and outdoor activities. Her father sent her to school in Lenox, Massachusetts, where she studied under intelligent and independent teachers. She grew up to be a strong, determined woman who broke the social norms of Victorian womanhood.[1]

Sculpture was an unheard-of profession for an American woman when Hosmer decided on her future career. She studied in Boston under Paul Stevenson but, as a woman, was not able to learn anatomy until 1850, when she received private instruction at Washington University, in Saint Louis. Hosmer went to Rome in 1852, where she studied for seven years in the studio of British sculptor John Gibson. She flourished in Rome, making friends, working hard, and learning quickly. Hosmer began to model statues influenced by mythological subjects and the art of antiquity, including a popular *Puck* seated on a toadstool (1856), a large *Zenobia* (1861), and a *Sleeping Faun* (1865). She also created pleasant, idealized portraits. Her academic but

Cupid on Dolphin (*left*) IS PROBABLY THE FIGURE TO THE RIGHT AT THE BASE OF THE PEDESTAL (*above*) IN *Fountain of the Siren* (1861). COURTESY OF THE WATERTOWN FREE PUBLIC LIBRARY.

poignant neoclassical sculptures appealed to the romantic sensibility of the Victorian era, and Hosmer became the leading female sculptor of her age.[2]

In the winter of 1860, she met Marian, viscountess Alford, an Englishwoman taking an Italian holiday. The widow of the viscount Alford and daughter of the second marquess of Northampton, she soon became an important patron and friend. Not long after they met, Hosmer created *Fountain of the Siren* (1861) for Lady Marian's house in London. The sculptural group consisted of a raised pool of water with a tall pedestal in the center. A large shell sat atop it, and inside the shell was a seated female figure holding a flute or pipes. Encircling the base of the pedestal, seemingly floating on the water, were four cupids riding dolphins, looking up toward the source of the song. An 1867 group photograph of Hosmer and her staff shows the fountain, or a replica, in her studio. The fountain either did not travel to London in 1861 as planned and instead stayed in Hosmer's studio for years, or Hosmer made a duplicate for herself. In recent years, Hosmer scholars have listed the *Fountain of the Siren* as unlocated.[3]

It is likely that Virginia's *Cupid on Dolphin* was originally one of the four sculptures around the base of the fountain. It depicts a nude boy balancing on the back of a strange-looking dolphin that resembles an ancient sea

creature. The cupid leans backward, gently cupping his left ear and turning his head, as if straining to hear the siren's pleasant song. The dolphin's spiraling tail, on which the cupid rests his right hand, is supported by a large, exotic plant. The effect is charming, elegant, and graceful.

At the end of 1867, an inventory of some items in Hosmer's studio included two "charming putti playing on the backs of dolphins," but their current locations are not known. It is not clear whether the two works are copies or originals from the fountain. These statues were listed as earmarked for her new patron, Louisa, baroness Ashburton, a friend of Lady Marian. It is apparently these two sculptures that have been passed down by the marquesses of Northampton to the present day. With the Virginia *Cupid on Dolphin*, they are the only three of their kind that are known. All three *Cupids* are the same size and have subtly different poses.[4]

Hosmer completed most of her major works in the 1860s. From the 1870s until late in the 1890s, she divided her time between studios in Rome and in England. Her last major work was a statue of Queen Isabella of Spain. Hosmer spent the final ten or fifteen years of her life in the United States and had a studio in Chicago in the 1890s before returning to Massachusetts about 1900, where she worked on a perpetual-motion machine, pursuing a lifelong interest in mechanical devices. Harriet Goodhue Hosmer died in Watertown on 21 February 1908.[5]

Virginia's *Cupid on Dolphin* was a gift to the Executive Mansion from Marion Elizabeth Moncure (Mrs. Robert V. H.) Duncan, of Alexandria, in 1976.

TLK

3. Dolly Sherwood, *Harriet Hosmer: American Sculptor, 1830–1908* (Columbia: University of Missouri Press, 1991), 205–206, 257, 358 n. 11.

4. Ibid., 267; the Northampton cupids are illustrated on 269. The daughter of Louisa, baroness Ashburton, the Honorable Mary Baring married William Compton, Lady Marian's nephew and later the fifth marquess of Northampton. In an interesting twist of fate, it is possible that the sculptures on the fountain originally meant for the wife of the second marquess came to the family through marriage.

5. "One Woman's Career," *Washington Post*, 1 March 1908, p. E2; Craven, *Sculpture in America*, 330.

REFERENCES

Craven, Wayne. *Sculpture in America*. New York: Thomas Y. Crowell Company, 1968.

Curran, Joseph L. Joseph L. Curran Papers concerning Harriet Goodhue Hosmer, 1845–1975. Watertown Free Public Library, Watertown, Mass. Microfilm on two reels at the Archives of American Art, Smithsonian Institution, Washington, D.C.

Groseclose, Barbara. "Hosmer, Harriet Goodhue." *American National Biography*, 11:241–242. New York and Oxford, Eng.: Oxford University Press, 1999.

Sherwood, Dolly. *Harriet Hosmer: American Sculptor, 1830–1908*. Columbia: University of Missouri Press, 1991.

NOTES

1. Wayne Craven, *Sculpture in America* (New York: Thomas Y. Crowell Company, 1968), 325–326.

2. Ibid., 326–328.

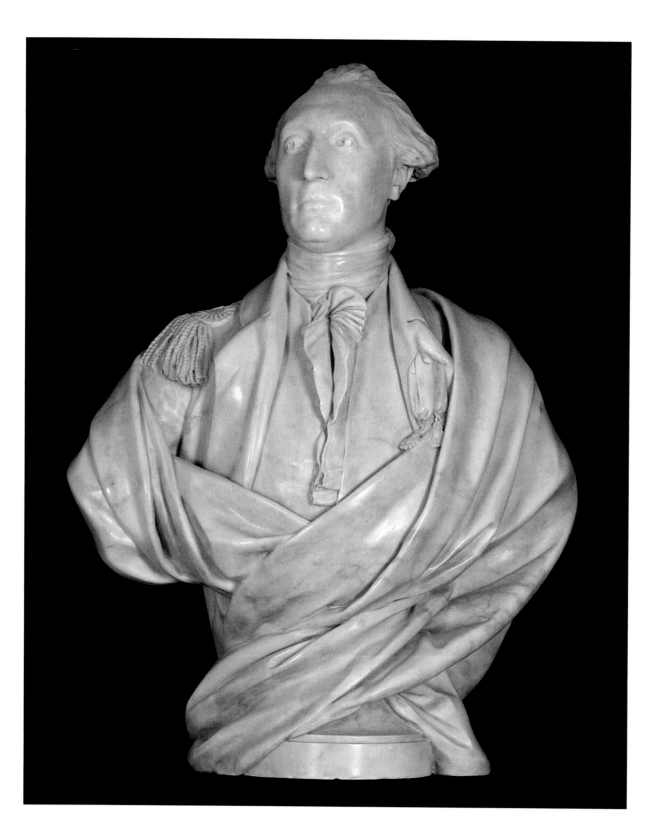

JEAN-ANTOINE HOUDON (1741–1828)

MARIE-JOSEPH-PAUL-YVES-ROCH-GILBERT DU MOTIER, MARQUIS DE LAFAYETTE (1757–1834)

1786
Marble
Height 35 inches
Inscribed on marble base "This bust was voted on the / seventeenth day of December seventeen / hundred & eighty one by the / GENERAL ASSEMBLY of the STATE OF VIRGINIA, / to the honor of the / MARQUIS de LA FAYETTE. / Major General in the service of the United / States of America, and late Commander / in Chief of the Army of the United States / in Virginia,) as a lasting monument of / his memory and their gratitude."
Collection of the Commonwealth of Virginia

Jean-Antoine Houdon was the finest sculptor in Europe during the final decades of the eighteenth century and the first decades of the nineteenth. Born the son of a household servant in Versailles, France, on 20 March 1741, he studied in Paris at the École Royale and under several artists, among them Michel-Ange Slodtz at the Académie Royale, Jean-Baptiste Lemoyne, and Jean-Baptiste Pigalle. Houdon won a prize that allowed him travel to Rome in 1764 where he studied at the Académie de France and explored the art of classical antiquity. After he returned to Paris four years later he achieved fame rapidly, modeling both portraits and idealized figures. In 1777 Houdon became a member of the Académie Royale and for the next fifty years executed numerous ideal sculptures and portraits of most of the leading men of the age, including encyclopedist Dénis Diderot, composer Christoph Willibald Gluck, American statesmen Benjamin Franklin and Thomas Jefferson, American naval hero John Paul Jones, and philosophers Jean-Jacques Rousseau and Voltaire. Houdon's marble bust of Lafayette and his full-length marble statue of George Washington, both executed under commissions from the Commonwealth of Virginia, are among his most admired works. Jean-Antoine Houdon died in Paris on 15 July 1828.[1]

Marie-Joseph-Paul-Yves-Roch-Gilbert du Motier de Lafayette was born on 6 September 1757 in Chavaniac, France. Orphaned young and succeeding to the title of marquis, he was attracted to the ideals and leaders of the American Revolution and in 1777 sailed for America. He secured a commission as a major general in the Continental army, and quickly earned the respect and affection of the commander in chief General George Washington. Lafayette speedily became an effective and popular officer. He served in the army until 1779, when he went home on leave, and then returned early in 1780 and commanded the army in Virginia during the months leading to the British defeat at Yorktown in October 1781. Lafayette persisted in his devotion to the cause of democracy and took part in the French Revolutions of 1789 and 1830 and repeatedly served in the National Assembly and as commander of the Paris National Guard. Consistently opposing arbitrary and undemocratic government, Lafayette suffered physically and financially. The Directory imprisoned him for five years during the 1790s, and he was out of favor during the rule of Napoleon. Lafayette returned to the United States for a triumphal two-year tour beginning in 1824. He died at his estate, La Grange, near Paris on 20 May 1834.[2]

In seeking to express gratitude for the part Lafayette took during the Revolution and for his service to Virginia, the General Assembly voted in December 1781 to procure a marble bust of the general with a suitable inscription for presentation to him. Three years later the assembly changed its mind and ordered two busts, one to be presented in gratitude to the City of Paris and the other for the Commonwealth of Virginia, to be "fixed in such public place at the seat of government as may hereafter be appointed for the erection of the Statue voted by

the General Assembly to General Washington." In 1785 the assembly passed an act of naturalization making Lafayette a citizen of Virginia.[3]

Asked by Governor Benjamin Harrison in 1784 to suggest "one of the best artists that can be procured," Thomas Barclay, American consul at Nantes, named Houdon. Harrison also sought advice from Thomas Jefferson and Benjamin Franklin about a sculptor for the statue of George Washington, commissioned by the General Assembly that year. Barclay and Thomas Jefferson corresponded about the commissions, and it is likely that Jefferson had some influence on the decision to choose Houdon to execute the bust of Lafayette. Houdon made a life mask of the almost-twenty-eight-year-old Lafayette during the first half of July 1785, before Houdon traveled to America late that month to study George Washington. Houdon completed the two marble busts early in 1786. The first bust was installed in the great hall of the Hôtel de Ville in September, and Houdon exhibited the second in the Paris Salon of 1787 before it was shipped to Virginia in November 1788. When the bust arrived in Richmond early in April 1789, it was discovered that the nose had broken off during shipping, and a local craftsman was hired to repair it.[4]

Houdon portrayed Lafayette looking serenely upward. The expression is dignified and sensitive. Lafayette's hair is loosely tied and graceful curls tumble down his back. He wears an American military uniform and from his lapel hang the cross of the Order of Saint Louis and the badge of the Society of the Cincinnati. Encircling this static core is dramatic, flowing baroque drapery. The overall effect is a combination of quiet dignity and grandeur.

As he did with the Washington statue, Houdon objected to the length of the pedestal inscription that the General Assembly specified for Virginia's bust and instead provided a formal, truncated Ionic column and possibly a square plinth, inscribed simply "LA FAYETTE." The assembly's inscription (missing an opening parenthesis after "America,") was later carved onto a tablet that in recent years has been mounted on the front of a square base.[5]

Although it is not documented where Lafayette's bust was displayed between 1789 and 1796, likely it was within the State Capitol. When the building was completed, both of Houdon's works were placed "in close proximity" to each other in the Rotunda, according to the assembly's wishes. Certainly Lafayette would have been pleased that he has been "eternally by the side of, and paying an everlasting homage to, the statue of my beloved general."[6]

<div style="text-align:center">TLK</div>

NOTES

1. Monique Barbier, "Abbreviated Chronology of Houdon's Life and Career," in *Jean-Antoine Houdon: Sculptor of the Enlightenment*, ed. Anne L. Poulet et al. (Washington, D.C.: The National Gallery of Art, in Association with the University of Chicago Press, 2003), 347–354. See also Charles Henry Hart and Edward Biddle, *Memoirs of the Life and Works of Jean Antoine Houdon, the Sculptor of Voltaire and of Washington* (Philadelphia: Printed for the Authors, 1911); Georges Giacometti, *La Vie et L'Oeuvre de Houdon*, 2 vols. (Paris: A. Camoin, 1929); and H. Harvard Arnason, *The Sculptures of Houdon* (London: Phaidon, 1975).

2. Stanley J. Idzerda, "Lafayette, Marquis de," *American National Biography* (New York and Oxford, Eng.: Oxford University Press, 1999), 13:37–38.

3. William Waller Hening, *The Statutes at Large; Being a Collection of All the Laws of Virginia* . . . (Richmond: Printed for the Editor by George Cochran, 1823; facsimile reprint, Richmond: Whittet & Shepperson, 1969), 10:569–570; *Journal of the House of Delegates [Oct. 18, 1784–Jan. 7 1785]* (Richmond, Va., 1785), 39–40 (quotation); Hening, *Statutes at Large*, 11:553; *Acts Passed at a General Assembly of the Commonwealth of Virginia* . . . *[1785]* (Richmond: John Dunlap and James Hayes, [1786]), 8.

4. Benjamin Harrison to Thomas Barclay, 5 April 1784, in Letter Book of Benjamin Harrison, 1783–1786, pp. 294–295, Virginia, Governor's Office, Executive Letter Books, 1780–1860, Accession 35358, State Government Records Collection, The Library of Virginia, Richmond. Nearly four months after his letter to Barclay, Harrison

wrote to Jefferson in July (Letter Book of Benjamin Harrison, 1783–1786, pp. 369–371), and later to Franklin as well. The life mask descended in Lafayette's family and now is in the collection of the Herbert F. Johnson Museum of Art at Cornell University (Poulet, *Jean-Antoine Houdon*, 261). Thought to have been destroyed during the French Revolution, the first bust was rescued by Houdon and sold with his possessions at his death; it is unlocated (ibid., 259). For repair of the nose, see Joseph Jones to James Madison, 5 April 1789, in *The Papers of James Madison*, ed. Charles F. Hobson et al. (Charlottesville, Va.: University Press of Virginia, 1979), 12:48–49.

5. Thomas Jefferson to James Madison, 8 February 1786, in *The Papers of Thomas Jefferson*, ed. Julian P. Boyd and Mina R. Bryan (Princeton: Princeton University Press, 1954), 9:265–266; "Memorandum of Houdon," dated September 1786, Jefferson Papers, Library of Congress, as reprinted in *Houdon in America: A Collection of Documents in the Jefferson Papers in the Library of Congress*, ed. Gilbert Chinard (Baltimore: The Johns Hopkins Press, 1930), 37. The square plinth could also have been sent by Houdon. It is plausible that Houdon could have sent his own plinth with only the name, instead of the long dedication, to parallel his solution in his struggle against the Washington statue inscription. A photograph of the column and plinth taken by Harry C. Mann for the Jamestown Exposition Company in 1906 is in Amy Waters Yarsinske, *Jamestown Exposition: American Imperialism on Parade*, vol. 1, *Images of America* (Charleston, S.C.: Arcadia, 1999), 92.

6. Lafayette to Washington, 26 October 1786, quoted in Hart and Biddle, *Memoirs of the Life and Works of Jean Antoine Houdon*, 235.

REFERENCES

Arnason, H. Harvard. *The Sculptures of Houdon*. London: Phaidon, 1975.

Chinard, Gilbert, ed. *Houdon in America: A Collection of Documents in the Jefferson Papers in the Library of Congress*. Baltimore: The Johns Hopkins Press, 1930.

Giacometti, Georges. *La Vie et L'Oeuvre de Houdon*. 2 vols. Paris: A. Camoin, 1929.

Hart, Charles Henry, and Edward Biddle. *Memoirs of the Life and Works of Jean Antoine Houdon, the Sculptor of Voltaire and of Washington*. Philadelphia: Printed for the Authors, 1911.

Idzerda, Stanley J. "Lafayette, Marquis de." *American National Biography*, 13:37–38. New York and Oxford, Eng.: Oxford University Press, 1999.

Poulet, Anne L., et al. *Jean-Antoine Houdon: Sculptor of the Enlightenment*. Washington, D.C.: The National Gallery of Art, in Association with the University of Chicago Press, 2003.

Unger, Harlow G. *Lafayette*. New York: John Wiley & Sons, 2002.

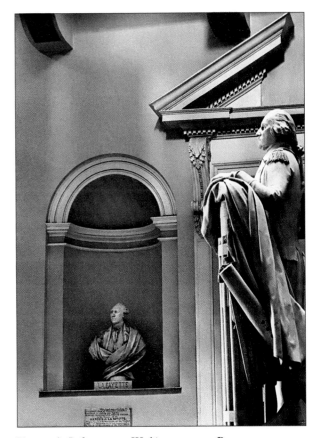

HOUDON'S *Lafayette* AND *Washington* IN THE ROTUNDA, CA. 1930

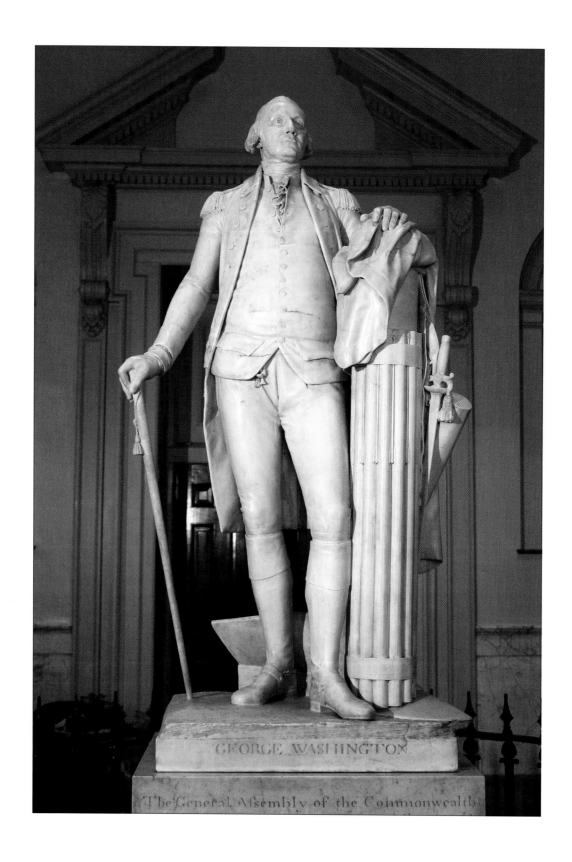

JEAN-ANTOINE HOUDON (1741–1828)
GEORGE WASHINGTON (1732–1799)

1785–1792

Marble

Height of statue 79½ inches; height with pedestal 131 inches

Inscriptions: On base of statue at front "GEORGE WASHINGTON"; on base of statue at proper right side "fait par houdon, Citoyen français, 1788."
On pedestal at front "The General Assembly of the Commonwealth / of Virginia have caused this statue to be erected, / as a monument of affection and gratitude to / GEORGE WASHINGTON / who, uniting to the endowments of the *Hero* / the virtues of the *Patriot*, and exerting both / in establishing the Liberties of his Country / has rendered his name dear to his Fellow-Citizens, / and given the world an immortal example / of true Glory. ~ Done, in the year of / CHRIST / One thousand seven hundred and eighty eight / and in the year of the Commonwealth the twelfth"

Collection of the Commonwealth of Virginia

In June 1784, a few months before the Virginia General Assembly revived its plan to honor the marquis de Lafayette with a portrait bust, it resolved to honor General George Washington with "a monument of affection and gratitude" by commissioning a statue of him to be "of the finest marble and best workmanship." The assembly ordered that the two likenesses be displayed together at the seat of government in Richmond. Governor Benjamin Harrison instructed Thomas Jefferson and Benjamin Franklin, who were then representing the United States in France, to select an appropriate sculptor for the commission. The governor also wrote to Charles Willson Peale, of Philadelphia, to order a full-length painting to serve as a model for the sculptor. Thomas Jefferson sent a letter to Washington in December 1784 recommending French sculptor Jean-Antoine Houdon.[1]

Houdon was eager to sculpt the statue of Washington, but he was unwilling to work from a portrait and insisted on making a study of Washington from life. Thus, Houdon traveled to the United States and spent nearly two weeks at Mount Vernon, beginning on 2 October 1785, taking detailed measurements, making a life mask (now in the collection of the Morgan Library, New York),

and creating a terra-cotta bust, which is still in the collection of Mount Vernon.[2]

As Houdon prepared to model the figure, he consulted with Jefferson about the matter of dress. Jefferson in turn wrote to Washington, who replied in August 1786:

> In answer to your obliging enquiries respecting the dress, attitude &c which I would wish to have given to the Statue in question—I have only to observe, that not having a sufficient knowledge in the art of sculpture to oppose my judgment to the taste of Connoisseurs, I do not desire to dictate in the matter—on the contrary I shall be perfectly satisfied with whatever may be judged decent and proper. I should even scarcely have ventured to suggest that perhaps a servile adherence to the garb of antiquity might not be altogether so expedient as some little deviation in favor of the modern custom, if I had not learnt from Colo. Humphreys that this was a circumstance hinted in conversation by Mr. West to Houdon.—This taste, which has been introduced in painting by West, I understand is received with applause & prevails extensively.[3]

Although, as an admirer of the art of antiquity, he had already made busts of Washington *a là antique*, Houdon clothed the general in his Revolutionary uniform,

not only to satisfy Washington's taste but also because he probably realized that Americans would not appreciate a statue of their leader depicted in antique garb. Houdon astutely combined Revolutionary-era details with an ancient subject and a naturalistic style to create an Americanized classicism. He portrayed Washington as a modern Cincinnatus, a role that Washington himself consciously adopted in admiration of the ancient Roman farmer and general who, after leading his armies to victory, returned to his farm as a peaceful civilian. Houdon masterfully combined ancient and modern styles and symbols suggesting both civilian and military virtues. Washington appears in his military uniform but holds a civilian walking cane with his proper right hand. To the left of and behind the general is a farmer's plowshare. He rests his proper left hand on a fasces, an ancient emblem of authority. Houdon gave the fasces an American context by combining thirteen rods to symbolize the original colonies with arrows in between to represent either the American Indians or the untamed wilderness. Thus, by representing Washington couched in Roman symbolism, Houdon added a layer of meaning that the American public would surely understand—an example of great power in harmony with democracy. The sculptor astutely combined French and American tastes with America's own values to create a uniquely American statue.

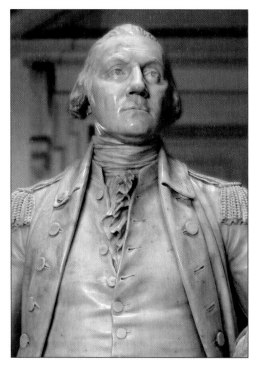

While working on the statue, Houdon complained to Jefferson that the inscription the assembly specified for the pedestal was too long. Houdon may have believed that a long inscription would require that the base be too high for proper viewing of the statue. The assembly refused to alter the inscription, which James Madison may have composed, and Houdon did not inscribe the pedestal before shipping the completed work to Virginia. The only inscriptions were on the statue itself: a simple "GEORGE WASHINGTON" on the front of the sculpture's base, and the artist's signature and date on the proper right side. In 1813 the longer inscription was carved into the base, with the additional, but incorrect, date of 1788 for the statue. Houdon was still modeling in 1789 and did not complete the marble sculpture until November 1792.[4]

Because Virginia's new State Capitol was still incomplete as Houdon finished the statue, shipment of the marble was delayed. Early in May 1796 three cases containing the statue and pedestal arrived in Richmond. The statue was erected in the Capitol's Rotunda on 14 May 1796 and still stands in the place Jefferson planned for it. Houdon's statue received instant acclaim. The artist's careful recording of the face and posture yielded a portrait that is naturalistic and lifelike. Houdon captured details that add to the overall effect, such as worry lines on Washington's brow and buttons left unbuttoned, indicating that Washington, though a great man, was a real man and not a god. Houdon's statue and terra-cotta bust are considered the most accurate likenesses of Washington ever made and have served as models for artists since the eighteenth century.

In the 1840s, in the 1850s, and again in the early years of the twentieth century, the General Assembly authorized artists to create molds for casting bronze or plaster copies of the statue. When it realized the damage that was being done to the statue, however, the legislature finally halted all mold-making campaigns in 1910. An appropriation from the General Assembly in 2000 permitted a thorough and careful cleaning of the statue, removing stains and grime, repairing previous damage, and once again revealing the fine detail and careful craftsmanship of the masterpiece of one of the world's great sculptors.[5]

TLK

NOTES

1. *Journal of the House of Delegates [May 3–June 1784]* (Richmond, Va., 1784), 100 (quotation); Benjamin Harrison to Thomas Jefferson, 20 July 1784, in *The Papers of Thomas Jefferson*, ed. Julian P. Boyd, Mina R. Bryan, and Elizabeth L. Hutter (Princeton: Princeton University Press, 1953), 7:378–379; Benjamin Harrison to Charles Willson Peale, 1 July 1784, in *The Selected Papers of Charles Willson Peale and His Family*, ed. Lillian B. Miller, Sidney Hart, and Toby A. Appel (New Haven and London: Yale University Press for the National Portrait Gallery, Smithsonian Institution, 1983), 1:413 (Peale's portrait of Washington is now in the collection of the Fogg Art Museum, Harvard University); Jefferson to Washington, 10 December 1784, George Washington Papers at the Library of Congress, 1741–1799: Series 4, General Correspondence, 1697–1799.

2. Anne L. Poulet et al., *Jean-Antoine Houdon: Sculptor of the Enlightenment* (Washington, D.C.: The National Gallery of Art, in Association with the University of Chicago Press, 2003), 263, 265.

3. Thomas Jefferson to George Washington, 4 January 1786, Washington Papers, Library of Congress; George Washington to Thomas Jefferson, August 1, 1786, The Thomas Jefferson Papers, Series 1: General Correspondence, 1651–1827, Library of Congress. American expatriate Benjamin West (1738–1820) is given credit for the break with the artistic tradition of placing historical events in antique clothing and settings when he introduced the use of contemporary dress in historical paintings with his *Death of General Wolfe* (1770, National Gallery, Ottawa) at London's Royal Academy of Arts exhibition in 1771. Helmut von Erffa and Allen Staley, *The Paintings of Benjamin West* (New Haven and London: Yale University Press, 1986), 55, 57.

4. Thomas Jefferson to James Madison, 8 February 1786, in *Papers of Thomas Jefferson*, 9:265–266. For the addition of the inscription, see invoice for work, 5 March 1813, in Auditor of Public Accounts (1776–1928), Capitol Square Data, Records, 1776–1971 (bulk 1785–1850), Accession 40418, State Government Records Collection, The Library of Virginia, Richmond. Houdon held a public viewing of the completed marble in his studio in November 1792 (Poulet, *Jean-Antoine Houdon*, 268). Houdon did have a reason to antedate his marble, however; the original agreement with the Commonwealth stipulated that the statue be completed within three years.

5. Tracy L. Kamerer and Scott W. Nolley, "Rediscovering an American Icon: Houdon's Washington," *Colonial Williamsburg* 25 (Autumn 2003): 74–79. Thirty-three bronze and plaster replicas have been permitted to date (78).

REFERENCES

Chinard, Gilbert, ed. *Houdon in America: A Collection of Documents in the Jefferson Papers in the Library of Congress.* Baltimore: The Johns Hopkins Press, 1930.

Hallam, John Stephen. "Houdon's Washington in Richmond Re-Examined." Master of Arts thesis, University of Washington, 1974.

Hart, Charles Henry, and Edward Biddle. *Memoirs of the Life and Works of Jean Antoine Houdon, the Sculptor of Voltaire and of Washington.* Philadelphia: Printed for the Authors, 1911.

Kamerer, Tracy L., and Scott W. Nolley. "Rediscovering an American Icon: Houdon's Washington." *Colonial Williamsburg* 25 (Autumn 2003): 74–79.

McRae, Sherwin. *Washington: His Person as Represented by the Artists. The Houdon Statue, Its History and Value.* Senate Doc. No. 21. Published by Order of the Senate of Virginia. Richmond: R. F. Walker, Superintendent of Public Printing, 1873.

Poulet, Anne L., et al. *Jean-Antoine Houdon: Sculptor of the Enlightenment.* Washington, D.C.: The National Gallery of Art, in Association with the University of Chicago Press, 2003.

WILLIAM JAMES HUBARD
(1807–1862)
JOHN TAYLOR OF CAROLINE
(1753–1824)

Ca. 1850
Oil on canvas
30 inches x 25 inches
Collection of the Library of Virginia, gift of the State
Agricultural Society

Born in England on 20 August 1807, William James Hubard earned renown early in life as a skilled cutter of silhouette profiles. As the primary artist in the Hubard Gallery, a group of silhouette cutters, he toured England, Scotland, and Ireland practicing his trade. Glasgow admirers of his skill presented him with an engraved silver palette, now in the collection of the Valentine Richmond History Center. In the summer of 1824 he and the Hubard Gallery crossed the Atlantic and arrived within a few days of the marquis de Lafayette, who was beginning his tour of the United States at the invitation of the government. Hubard cut a silhouette of the Frenchman, and his gallery met with such success that it remained in New York for a year before it began traveling in November 1825. By January 1828 Hubard had disassociated himself from the gallery, which eventually returned to England.[1]

Hubard studied oil painting, possibly with Gilbert Stuart, of Boston, and received advice from Robert S. Weir and Thomas Sully, of Philadelphia. He showed his work at the annual exhibition of the Boston Athenaeum in 1827 and at the Pennsylvania Academy of the Fine Arts in 1829 and 1831. In 1832, while living in Baltimore, he exhibited four paintings at the Pennsylvania Academy of the Fine Arts, including two portraits in small of Henry Clay and John C. Calhoun. Hubard also painted portraits in small of John Marshall and Andrew Jackson and may have painted one of Daniel Webster. The portrait of Clay, also exhibited at the American Academy of Fine Arts in 1833, was engraved by James Barton Longacre.[2]

Hubard's earliest Virginia portraits date to 1830. By the time he moved to the state about 1833, Hubard was concentrating on larger, bust-length portraits. Late in the 1830s he traveled to Europe to study in Paris and in Italy, where he became friends with sculptors Hiram Powers and Horatio Greenough. Hubard painted the latter in his studio, a portrait now in the collection of the Valentine Richmond History Center, and heard from him the story about King Philip (Metacom), a Wampanoag, who had led an Indian uprising against the English colonists in the 1670s. While in Florence, Hubard painted *Philip of Mount Hope rescuing the body of one of his chiefs* and sent it to New York for the October 1839 and February 1840 Apollo Association exhibitions. Hubard returned to Virginia in October 1841 and settled in Richmond. He continued to exhibit works, in Philadelphia at the Pennsylvania Academy of the Fine Arts in 1844 and 1848, and, in New York, at the National Academy of Design in 1847 and at the American Art-Union in 1847 and 1848.[3]

In 1853 Hubard printed a circular advertising his intention to cast bronze copies of Houdon's marble statue of George Washington, which he regarded as the "only reliable likeness of Washington extant." He received an exclusive right from the General Assembly to cast copies for seven years and intended to produce full-length copies at one-third the size of the original and to produce busts as well. Hubard successfully cast at least six statues. Following the outbreak of the Civil War, he prepared his foundry to cast cannons for the Confederate States of America. After his first efforts were rejected, he employed a new molder from the Tredegar Iron Works and cast a cannon that won approval. In her diary, his wife documented her husband's struggles with the foundry as he worked to cast cannons. On 13 February 1862 an explosion at the foundry severely burned Hubard and injured his hands, requiring amputation of several fingers. William James Hubard died in Richmond on 15 February, his wife and children by his side.[4]

About 1850 Hubard painted a portrait of John Taylor, known as John Taylor of Caroline, who was born in Caroline County, Virginia, on 19 December 1753. He studied at the College of William and Mary and was admitted to the bar in Caroline County in 1774. Taylor served in the army during the Revolutionary War but resigned in 1779. That same year he was elected to the

House of Delegates, where he served until 1781, from 1783 to 1785, and again from 1796 to 1800. In 1792 the General Assembly elected Taylor to succeed Richard Henry Lee in the United States Senate. He won reelection in 1793 but resigned in 1794. Taylor also served in the U.S. Senate from June to December 1803 and again from 1822 until his death on 21 August 1824 in Caroline County.[5]

Taylor was an influential political writer and also widely known as an agricultural reformer and for his innovative farming practices at Hazelwood, his farm in Caroline County. In *Arator: Being a Series of Agricultural Essays, Practical and Political*, published in 1813, Taylor elaborated on the need for Virginia to promote its agricultural resources and the related Jeffersonian ideal of an agrarian society. In addition to his political thought, the book included practical advice on such topics as crop rotation, an effective means of fertilizing soil, and the care of livestock. In 1811 Taylor was the founding president of the Virginia Society for Promoting Agriculture. The society and other local agricultural groups held fairs with premiums given to a wide variety of agricultural products and also advocated agricultural reform.[6]

Hubard's portrait of Taylor, probably a copy from a miniature or earlier oil portrait, clearly demonstrates the artist's careful attention to detail and skill in using light and shadow to model the face and to present a strong presence of the sitter. The portrait originally belonged to the State Agricultural Society, which disbanded in the 1890s. The society's last president, William Fanning Wickham, gave it and the society's other artworks to the commonwealth of Virginia, in order that the public would have free access to them. Joseph T. Lawless, secretary of the commonwealth and state librarian, wrote that he had "made an earnest but unsuccessful effort to secure a portrait of John Taylor before this one was obtained, and it is a matter for special congratulation that the State has at last become the custodian of a portrait of one of her most eminent citizens."[7]

BCB

NOTES

1. Biographical information is from Helen McCormick's essay in *William James Hubard, 1807–1862: A Concurrent Exhibition* (Richmond: The Valentine Museum and the Virginia Museum of Fine Arts, 1948), 3–15.

2. Mary Bartlett Cowdrey, *American Academy of Fine Arts and American Art-Union, 1816–1852* (New York: New-York Historical Society, 1953), 77:193. Portraits in small are full-length portraits that usually measure no more than 24 inches by 24 inches.

3. *William James Hubard, 1807–1862*, 6–9; Cowdrey, *American Academy of Fine Arts and American Art-Union, 1816–1852*, 77:193–194; Anna Wells Rutledge, *Cumulative Record of Exhibition Catalogues: The Pennsylvania Academy of the Fine Arts, 1807–1870; the Society of Artists, 1800–1814; the Artists' Fund Society, 1835–1845* (Philadelphia: American Philosophical Society, 1955), 104; National Academy of Design, *National Academy of Design Exhibition Record, 1826–1860* (New York: Printed for the New-York Historical Society, 1943), 74:241.

4. In his circular, Hubard lamented the loss of Antonio Canova's 1816 statue of Washington when the North Carolina capitol building burned in 1831. Noting that the skylight above the Houdon Washington in the Rotunda of the Virginia State Capitol leaked and was not in good condition, Hubard was fearful that a collapse or other calamity might severely damage or destroy the Houdon piece. See William James Hubard, *Circular of W. J. Hubard, Relative to Houdon's Statue of Washington, September 17th, 1853* (Richmond, 1853), Valentine Richmond History Center. The replicas are at the Virginia Military Institute, on the North Carolina Capitol grounds in Raleigh, in Lafayette Park in Saint Louis, in the U.S. Capitol Rotunda, at Miami University in Ohio, and in Columbia, South Carolina. Mabel M. Swan, "Master Hubard, Profilist and Painter," *The Magazine Antiques* 15 (1929): 496–499; *William James Hubard, 1807–1862*, especially 14–15; Maria Mason Tabb Hubard, Diary, 1860 May 1–1862 August 16, Mss5:1 H8614:1, The Virginia Historical Society, Richmond.

5. Robert E. Shalhope, "Taylor, John," *American National Biography* (New York and Oxford, Eng.: Oxford University Press, 1999), 21:382–384.

6. Charles W. Turner, "Virginia State Agricultural Societies, 1811–1860," *Agricultural History* 38 (July 1964): 167.

7. Annual report of J. T. Lawless (Spring 1900), printed in *Journal of the Senate . . . Begun . . . December 6, 1899* (Richmond: J. H. O'Bannon, Superintendent of Public Printing, 1899), 656 (quotation).

REFERENCES

Hubard, Maria Mason Tabb. Diary, 1860 May 1–1862 August 16. Mss5:1 H8614:1. The Virginia Historical Society, Richmond.

Shalhope, Robert E. *John Taylor of Caroline: Pastoral Republican*. Columbia: University of South Carolina Press, 1980.

_____. "Taylor, John." *American National Biography*, 21:382–384. New York and Oxford, Eng.: Oxford University Press, 1999.

Swan, Mabel M. "Master Hubard, Profilist and Painter." *The Magazine Antiques* 15 (1929): 496–499.

Turner, Charles W. "Virginia State Agricultural Societies, 1811–1860." *Agricultural History* 38 (July 1964): 167–177.

William James Hubard, 1807–1862: A Concurrent Exhibition. Richmond: The Valentine Museum and the Virginia Museum of Fine Arts, 1948.

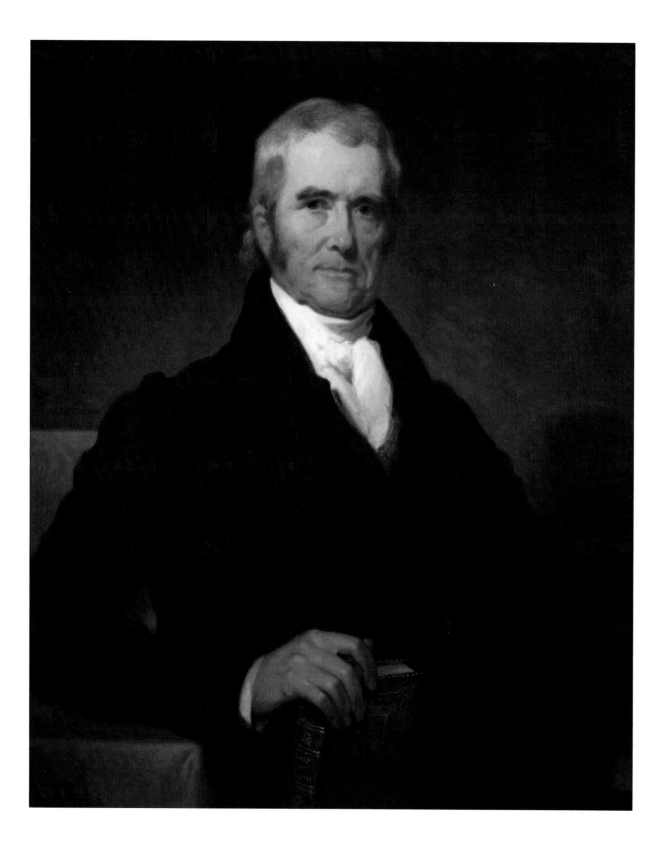

HENRY INMAN (1801–1846)
JOHN MARSHALL (1755–1835)

1832
Oil on canvas
36 inches x 29 inches
Collection of the Library of Virginia, bequest of Emily Harvie

Born in Utica, New York, on 20 October 1801, Henry Inman showed artistic talent as a child and received drawing lessons from an itinerant teacher. In 1812 his family moved to New York, a city that offered numerous resources for a young artist. Two years later he was apprenticed to the painter John Wesley Jarvis, with whom he spent seven years. Inman quickly became a valued assistant and eventually began painting the backgrounds and drapery behind Jarvis's portraits. Throughout his career, Inman painted miniatures, landscapes, and genre scenes, but his main focus remained on portraiture. He opened his own studio in New York in 1822 and became the leading portrait artist in the city, building a reputation and generating a significant amount of business.[1]

Inman first exhibited at the American Academy of Fine Arts in 1823 and was a principal in establishing the organization that became the National Academy of Design in 1826. He was its first vice president from 1827 until he became acting president in 1830. In 1831 Inman moved to Philadelphia as partner in a short-lived lithographic printing and publishing company. He received a warm welcome and numerous commissions in the city and executed a number of portraits of clergymen before he moved to New Jersey in 1832. Inman returned to New York in 1834 and continued his busy schedule until his fortunes and health started to fail early in the 1840s, and his work suffered. In 1844 he went to England in search of improved health and renewed artistic creativity. While there he completed several significant commissions he had received while in New York to finance the journey, including a portrait of William Wordsworth that he painted in Scotland. The trip seemed to reinvigorate his work, but in the spring of 1845 failing health and homesickness forced Inman to return to New York, where he died on 17 January 1846 of asthma and an enlarged heart.[2]

While Inman was living in Philadelphia he received a commission from the Philadelphia Bar Association to paint a portrait of Chief Justice John Marshall, creating what has been called "arguably the finest and strongest portrait of Inman's career." Marshall was in Philadelphia late in September 1831 to consult with Dr. Philip Syng Physick, the famous surgeon, regarding his problem with bladder stones. Even though he was not well, Marshall was flattered and agreed to sit for Inman in his studio a few days before his operation, but the doctor declined to allow him to return for another sitting. The successful operation was performed at considerable risk.[3]

The seventy-six-year-old Marshall showed great stamina and character in sitting for Inman, although he must have been in considerable pain and quite uncomfortable. His face shows not age or pain but strength. Painted in Inman's soft, yet conservative brushwork, the revered chief justice looks straight out at the viewer in an energetic and engaging manner. Marshall is seated and balanced between his right hand and leg is a volume from his five-volume edition of *The Life of George Washington* (1804–1807).

Inman exhibited his portrait of Marshall at the Pennsylvania Academy of the Fine Arts in 1832, shortly after he had completed it. It still belongs to the Philadelphia Bar Association. The popular likeness has been exhibited and copied frequently, and Albert Newsam translated it into a lithograph in 1831 even before it was finished. Inman made a copy of the portrait for the engraver Asher B. Durand, later a renowned painter, who published it in the *National Portrait Gallery of Distinguished Americans* (1834–1839). Marshall bought Durand's copy of the painting for his daughter, Mary Marshall Harvie. Her daughters, Ann F. Harvie and Emily Harvie, deposited the portrait for safekeeping in the State Library in 1874. In 1920, Emily Harvie, the surviving sister, bequeathed it to the Library.[4]

TLK

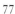

NOTES

1. William H. Gerdts, *The Art of Henry Inman*, Catalog by Carrie Rebora (Washington, D.C.: The National Portrait Gallery, Smithsonian Institution, 1987), 29–31.

2. Ibid., 33–47, 52–54, 56–57.

3. Andrew Oliver, *The Portraits of John Marshall* (Charlottesville: Published for the Institute of Early American History and Culture by the University Press of Virginia, 1977), 136; Gerdts, *The Art of Henry Inman*, 38 (quotation). It is said that Dr. Physick removed more than one thousand stones from Marshall. Gerdts, *The Art of Henry Inman*, 114.

4. James B. Longacre and James Herring, *The National Portrait Gallery of Distinguished Americans* (Philadelphia: H. Perkins, 1834–1839), 1:n.p.; Annual Report of the Librarian, 1 January 1875, Senate Doc. No. 23, *Journal of the Senate . . . [1874]* (Richmond: R. F. Walker, Supt. Public Printing, 1874), 4; *Journal of the House of Delegates . . . January 11, 1922* (Richmond: Davis Bottom, Superintendent of Public Printing, 1922), 126. The painting has been so widely copied that similar portraits of Marshall are referred to as "the Inman type." See Oliver, *The Portraits of John Marshall*, 135–163.

REFERENCES

Gerdts, William H. *The Art of Henry Inman*. Catalog by Carrie Rebora. Washington, D.C.: The National Portrait Gallery, Smithsonian Institution, 1987.

Oliver, Andrew. *The Portraits of John Marshall*. Charlottesville: Published for the Institute of Early American History and Culture by the University Press of Virginia, 1977.

Rebora, Carrie. "Inman, Henry." *American National Biography*, 11:664–665. New York and Oxford, Eng.: Oxford University Press, 1999.

Smith, Jean Edward, et al. *The Face of Justice: Portraits of John Marshall*. Huntington, W. Va.: Huntington Museum of Art, Marshall University, 2001.

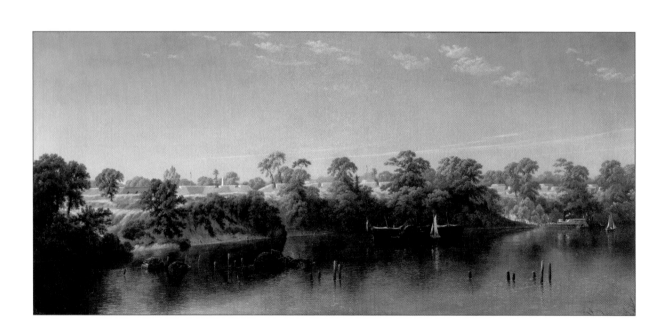

JOHN ROSS KEY (1832–1920)
DREWRY'S BLUFF, JAMES RIVER [FORT DARLING]

1865
Oil on canvas
22¼ inches x 48½ inches
Inscribed at lower left corner "J. R. Key / 1865"
Collection of the Executive Mansion

A landscape painter and draftsman, John Ross Key was born on 16 July 1832 in Hagerstown, Maryland, and raised by his famous grandfather, Francis Scott Key, in Washington, D.C. Key's early life and education are not well documented, and the few existing accounts are contradictory and sketchy. As a young man he worked as a draftsman for the United States Coast Survey of 1853–1856, after which he was a practicing artist in Boston. When the Civil War broke out, Key returned to the South and became a lieutenant in the Confederate army. His military record indicates that he was a draftsman in the Engineer Department on 24 March 1862, with assignments in Richmond and in Charleston, South Carolina. During the war, Key recorded what he saw, including the attack on Fort Sumter in 1861 that began the war. After the war, Key painted dramatic landscape scenes all around the country, many of which were translated into lithographs. He won a gold medal for his painting of San Francisco's Golden Gate at Philadelphia's Centennial Exposition in 1876. John Ross Key returned to his hometown of Baltimore several years before his death there on 24 March 1920.[1]

Key moved between Charleston and Richmond during the war and probably had several opportunities to see Drewry's Bluff, seven miles south of Richmond, on the south bank of the James River in Chesterfield County. The bluff rises ninety feet above the water and during the war was an obvious location for defensive fortifications to protect Richmond, the capital of the Confederate States of America. On this site the men of Captain August H. Drewry's Southside Artillery constructed a fort, earthworks, artillery emplacements, and barracks. Northerners referred to the site as Fort Darling, but it has been known in the South as Drewry's Bluff, named after Captain Drewry, the landowner.[2]

In this quiet panoramic scene, the viewer looks from the opposite riverbank toward the southwest at the fortifications, and the sun rises to the left. The morning air is perfectly still and clear, and the trees in full leaf indicate that it is probably spring or summer. In the foreground are sunken ruins of paddlewheel steamers and spiles (posts), which served as protection against the easy passage of enemy vessels, and in the background is an assortment of other ships.

Despite the date of 1865, the scene depicted could not have occurred that year. Key most likely sketched the scene in the summer of 1863. The Confederate naval school ship *Patrick Henry* is in the middle ground, and the ironclad ram CSS *Richmond* is in the background near a steamer, which is probably the *Schultz*. The ships all fly the first national flag, a pattern that was changed in May 1863. As was a common practice for artists of his day, Key painted the landscape in his studio later. While on exhibit at a Baltimore gallery during the summer of 1865, Key's depiction of Drewry's Bluff was the subject of a long and glowing review in the *Baltimore Daily Gazette* of 8 July 1865. The critic praised Key's ability to create a pleasing and artistic scene without sacrificing historical accuracy.[3]

The artist apparently painted at least three very similar scenes of Drewry's Bluff. Another painting of the scene, which is almost the same size, is attributed to Key and is in the collection of the Museum of the Confederacy, in Richmond. This painting shows a slightly different point of view and very different lighting: the sky is pink and the sun is setting low in the southwest. The composition was likely recorded on the same day in 1863 and includes most of the same vessels, although they display the second national (Confederate) flag. A signed painting of Drewry's Bluff, almost identical to the museum's, was offered for sale in New York in 1987.

In 1978 the Executive Mansion purchased Key's painting of Drewry's Bluff in the morning light.

TLK

NOTES

1. Alfred C. Harrison Jr., "Bierstadt's *Bombardment of Fort Sumter* Reattributed," *The Magazine Antiques* 129 (1986): 416–422, especially 419–420; Robert E. L. Krick, *Staff Officers in Gray: A Biographical Register of the Staff Officers in the Army of Northern Virginia* (Chapel Hill: The University of North Carolina Press, 2003), 193–194; George C. Groce and David H. Wallace, *The New-York Historical Society's Dictionary of Artists in America, 1564–1860* (New Haven and London: Yale University Press, 1957), 368.

2. "Drewry's Bluff," Richmond National Battlefield, National Park Service, <http://www.nps.gov/rich/ri_drew.htm> [30 January 2005].

3. "Drewry's Bluff, or Fort Darling," *Baltimore Daily Gazette*, 8 July 1865, p. 1. The author wishes to thank Dr. John Coski, of the Museum of the Confederacy, for assistance in identifying the vessels and flags and for information on the museum's painting of Drewry's Bluff.

REFERENCES

"Drewry's Bluff, or Fort Darling." *Baltimore Daily Gazette*, 8 July 1865, p. 1.

Harrison, Alfred C., Jr. "Bierstadt's *Bombardment of Fort Sumter* Reattributed." *The Magazine Antiques* 129 (1986): 416–422.

Krick, Robert E. L. *Staff Officers in Gray: A Biographical Register of the Staff Officers in the Army of Northern Virginia*. Chapel Hill: The University of North Carolina Press, 2003.

National Gallery of Art. *Catalogue of a Collection of Oil Paintings and Drawings by the Late John Ross Key (1837–1920), on View in the Central Room of the National Gallery, Natural History Building, U.S. National Museum, January 15 to February 6, 1927*. Washington: Government Printing Office, 1927.

Drewry's Bluff, James River (detail). Confederate school ship *Patrick Henry* is to the left with the ironclad ram CSS *Richmond* in the background (*at right*), near a steamer, perhaps the *Schultz.*

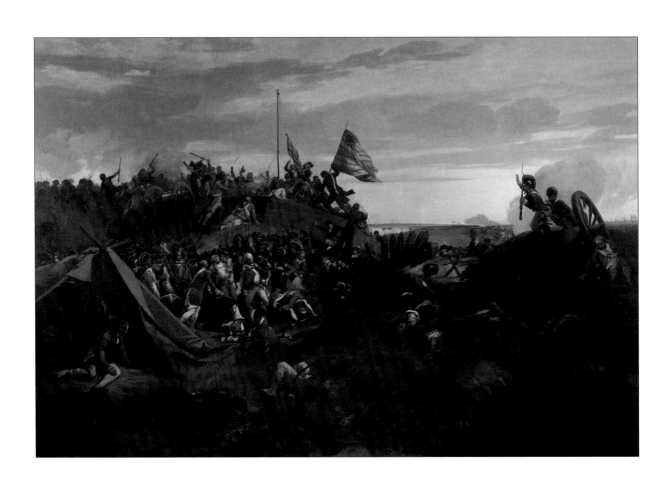

EUGÈNE LOUIS LAMI (1800–1890)
STORMING OF A BRITISH REDOUBT BY AMERICAN TROOPS AT YORKTOWN
[Enlèvement d'une Redoute Anglaise par les Troupes Américaines à Yorktown]

1840
Oil on canvas
132 inches x 176 inches
Inscribed at lower left "EUGENE LAMI 1840"
Collection of the Commonwealth of Virginia, gift of William Wilson Corcoran

Born in Paris on 12 January 1800, Eugène Louis Lami suffered from such delicate health as a child that he was schooled at home. The fifteen-year-old's sketches caught the attention of French artist Horace Vernet who invited Lami into his studio. In 1817 Lami began three years of study under Antoine-Jean Gros at the École des Beaux-Arts. His early works were drawings and lithographs, many reflecting his interest in military history. With assistance from Vernet, in 1822 he published a collection of 100 chromolithographs entitled *Collection des Uniformes des Armeés Françaises, de 1791 à 1814*, and in 1825 another 50 in *Collection Raisonnée des Uniformes Français, de 1814 à 1824*.[1]

Lami's debut at the Paris Salon came in 1824 with a military painting entitled *Combat de Puerto de Miravete, 30 Septembre 1823*. He soon made a name for himself as a talented painter of history and contemporary life, and his work caught the attention of King Louis-Philippe. During the 1830s the artist was occupied with royal commissions, mostly of military scenes. The king had decided to transform his palace at Versailles into a historical museum, and desired large paintings of great military events. After the museum opened in 1837, Lami was able to change his focus to recording courtly life and pageantry with the same eye for detail and skilled draftsmanship. During his long career he worked in France and in England and painted in oil and watercolor. He was a founder of the Société des Aquarellistes Français in 1879. Large collections of his art are at Versailles, at the Victoria and Albert Museum in London, and at Windsor Castle. Eugène Louis Lami died in Paris, France, on 19 December 1890.[2]

Lami painted *Storming of a British Redoubt* in 1840 as his vision of the dramatic moment of the victory of French and American forces over the British at Yorktown in October 1781. Lieutenant Colonel Alexander Hamilton rushes heroically into the center of the painting, sword raised, with his company behind him. The scene inside the fortification is of chaos; there has been an explosion at the right and fighting around the perimeter, and wounded men huddle in the tent. Hamilton's men are seen capturing the British commanding general, Charles Cornwallis, and at the top of the fortification the British flag is lowered and a new flag hoisted into place. General George Washington, commander in chief of the American forces, watches the activity from horseback in the middle ground, with the incoming French fleet and the outgoing British fleet visible on the horizon.

Lami produced the scene fifty-nine years after the event, without benefit of firsthand knowledge of the battle, terrain, or foreign military attire. It is obvious that he read accounts of the battle and likely saw maps and drawings of the scene. Some key details are correct, such as the shape of the redoubt and the location of the site near the York River with the fleet of Admiral François de Grasse, comte de Grasse, visible in the distance. Many other details of the battle, however, are not accurate. The most obvious invention is that Cornwallis was not apprehended during the battle, and he did not surrender until 19 October, five days after the action shown in the painting. Lami also creatively fabricated the details of the uniforms of the various forces. But for the painter of a historic event, such factual details take a backseat to the desire to synthesize the particulars of the battle for maximum dramatic effect. All would agree that he created a beautiful and exciting work of art that is perfectly appropriate to the significance of the historical event.[3]

Lami's two large American battle scenes, *Storming of a British Redoubt* and *The Battle of New Orleans*, may have been commissioned by Robert Morlot, a French importer living in New York. The paintings surfaced again in the possession of Z. B. Stearns, an art dealer, who offered them for exhibition and sale early in 1878 to William Wilson Corcoran's gallery in Washington, D.C. Corcoran was an avid art collector, gallery owner, and patron of the arts, but the paintings were in poor condition. William McLeod, curator of the Corcoran, found the paintings not to his taste and wrote, "There is much fine drawing and painting in them, but after all they are *far-far* behind in modern art!" Nevertheless, the paintings were of interest to visitors. Corcoran purchased the two paintings for $1,500 and donated *The Battle of New Orleans* to the State of Louisiana. He presented the *Storming of a British Redoubt* to the Commonwealth of Virginia, as "evidence of my admiration for the old Commonwealth, which has been justly designated as the Mother of Statesmen and Heroes." The painting was hung in the Virginia State Capitol on 9 October 1878 and remains in the room, now called the Old Senate Chamber, to this day.[4]

TLK

4. William McCleod, entry for 8 March 1878, Curator's Journal (15 January to 27 June 1878), Corcoran Gallery Papers, Archives of American Art, Smithsonian Institution, Washington, D.C.; W. W. Corcoran to Governor Frederick William Mackey Holliday, quoted in Treviranus, "Yorktown Postscript," 15–16; "City News in Brief," *Washington Post*, 10 October 1878, p. 4. *The Battle of New Orleans* is displayed in the Cabildo in New Orleans.

REFERENCES

Lemoisne, Paul-André. *Eugène Lami*. Paris: Manzi, Joyant, Goupil, 1912.

_____. *L'Oeuvre d'Eugène Lami*. Paris: H. Champion, 1914.

Treviranus, H. Stewart. "Yorktown Postscript," *Arts in Virginia* 15, no. 1 (Fall 1974): 12–21.

Turner, Jane, ed. "Lami, Eugène(-Louis)." *The Dictionary of Art*, 18:678–679. New York: Grove's Dictionaries, 1996.

NOTES

1. Paul-André Lemoisne, *L'Oeuvre d'Eugène Lami* (Paris: H. Champion, 1914), 366, 371; Jane Turner, ed., "Lami, Eugène(-Louis)," *The Dictionary of Art* (New York: Grove's Dictionaries, 1996), 18:678. See also Lemoisne, *Eugène Lami* (Paris: Manzi, Joyant, Goupil, 1912).

2. Lemoisne, *L'Oeuvre d'Eugène Lami*, ix, x, xiv; Turner, "Lami, Eugène(-Louis)," 18:679.

3. H. Stewart Treviranus, "Yorktown Postscript," *Arts in Virginia* 15, no. 1 (Fall 1974): 12–21.

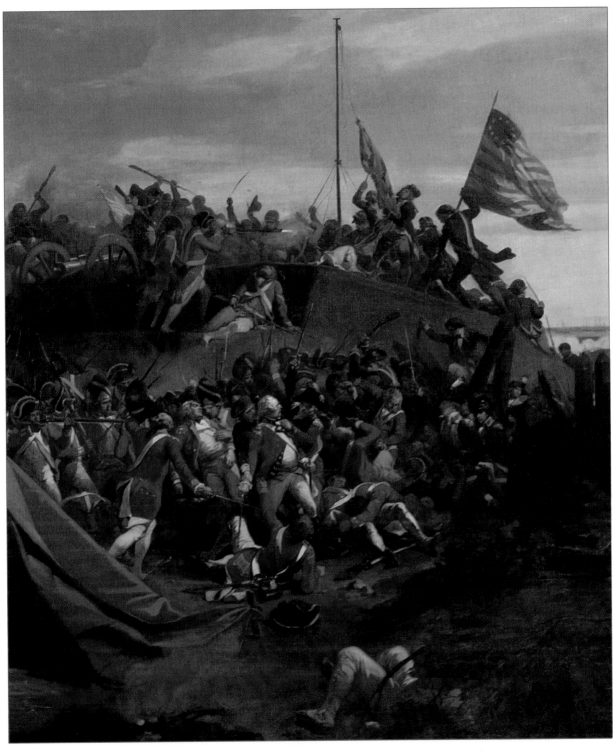

DETAIL OF LAMI'S IMAGINARY SCENE OF TRIUMPHANT CONTINENTAL ARMY SOLDIERS RAISING THE AMERICAN FLAG IN PLACE OF THE BRITISH UNION JACK AT THE BATTLE OF YORKTOWN (*top*) AND CORNWALLIS CAPTURED BY AMERICAN TROOPS (*center*)

JOHN LÉON MORAN (1864–1941)
NATURAL BRIDGE, VIRGINIA

1885
Oil on canvas
24 inches x 16 inches
Inscribed at lower left "J Moran. / 1885"
Collection of the Executive Mansion, gift of the General
Electric Company

In December 1974 the General Electric Company
gave the painting to the Executive Mansion.

BCB

Although he was related to four well-known American artists, much about the life and career of John Léon Moran remains unknown. Born in Philadelphia on 4 October 1864, he was the son of Edward Moran (1829–1901), an artist and his first teacher. Two uncles, Thomas Moran (1837–1926) and Peter Moran (1841–1914), were prominent landscape painters, and an older brother, Percy Moran (1862–1935), was known for his engravings. Preferring to use his middle name, Léon Moran studied at the National Academy of Design in New York and in London and Paris. He returned to New York in 1879 and established a studio there by 1883. He specialized in sentimental genre painting and exhibited regularly at the National Academy of Design from 1881 to 1920. Moran was elected a member of the American Water Color Society in 1886. He received gold medals at the Art Club of Philadelphia in 1893 and at the American Art Society in 1904. John Léon Moran died in Plainfield, New Jersey, on 4 August 1941.[1]

Natural Bridge, in Rockbridge County, Virginia, has inspired writers and artists since the eighteenth century. Thomas Jefferson bought the bridge and the surrounding property in 1774 and wrote in his *Notes on the State of Virginia* that "it is impossible for the emotions, arising from the sublime, to be felt beyond what they are here: so beautiful an arch, so elevated, so light, and springing, as it were, up to heaven, the rapture of the Spectator is really indiscribable!" The bridge appeared in prints as early as 1786, when a view was published in the marquis de Chastellux's *Voyages en Nord Amérique*. American landscape painters, including David Johnson and Frederic Edwin Church, began visiting the arch in the mid-nineteenth century. Moran's 1885 view reduces the dramatic sweep of the bridge but still conveys a sense of scale with a tiny figure in the lower right foreground. Reflecting his training in France, Moran painted the trees with quick, suggestive strokes and concentrated on the patterns of light filtering through the ravine.[2]

NOTES

1. "Moran, [John] Léon," *National Cyclopaedia of American Biography* (New York: James T. White and Company, 1943), 30:521–522; Nancy Siegel, *The Morans: The Artistry of a Nineteenth-Century Family of Painter-Etchers* (Huntingdon, Pa.: Juniata College Press, 2001), 12–13, 16–18.

2. Thomas Jefferson, *Notes on the State of Virginia*, ed. William Peden (Chapel Hill: University of North Carolina Press, for the Institute of Early American History and Culture at Williamsburg, Virginia, 1955), 25 (quotation). See also Pamela H. Simpson, *So Beautiful an Arch: Images of the Natural Bridge, 1787–1890* (Lexington, Va.: Washington and Lee University, 1982), for a discussion about artistic views of the natural wonder.

REFERENCES

"Moran, [John] Léon." *National Cyclopaedia of American Biography*, 30:521–522. New York: James T. White and Company, 1943.

Siegel, Nancy. *The Morans: The Artistry of a Nineteenth-Century Family of Painter-Etchers*. Huntingdon, Pa.: Juniata College Press, 2001.

Simpson, Pamela H. *So Beautiful an Arch: Images of the Natural Bridge, 1787–1890*. Lexington, Va.: Washington and Lee University, 1982.

ATTILIO PICCIRILLI (1866–1945)
JOY OF LIFE (YOUNG FAUN)

Modeled in 1898; date of bronze cast unknown
Bronze
Height 56 inches
Inscribed on top of base behind figure "Attilio Piccirilli / NY 1898"
Collection of the Executive Mansion, gift of the artist

Attilio Piccirilli was born on 16 May 1866 in Massa, Italy, a Tuscan village near the famous Carrara marble quarries. He was one of the six sons of Guiseppe Piccirilli and Barbara Giorgi Piccirilli to follow their father into the family stone-carving business. At the age of fourteen he entered the Accademia di Belle Arti di Roma, where he studied for five years. In search of work, Attilio and his family moved to London and then to New York, where he and his brothers opened a sculpture studio by 1890. The Piccirillis moved their business to the Bronx in 1893, and it eventually became one of the largest in the country. The six brothers were excellent artists themselves, but their studio is best known for carving the work of other artists. The Piccirillis carved architectural sculpture for prominent public buildings, such as the Brooklyn Museum and the Supreme Court of the United States, and they carved significant public monuments and statues, such as Daniel Chester French's monumental Abraham Lincoln for the Lincoln Memorial in Washington, D.C. Attilio Piccirilli completed his last major work, the Marconi Memorial, for Washington, D.C., on 30 June 1941. He died at his studio in the Bronx on 8 October 1945.[1]

Piccirilli became the most successful of the brothers in his own artistic career. He designed and carved the *Maine Monument* for New York's Central Park, the full-length statue of President James Monroe at Ash Lawn–Highland, in Albemarle County, Virginia, and the marble statue *Spirit of Youth* at the Virginia Military Institute. He also created the busts of Thomas Jefferson (1734–1826) and James Monroe (1758–1831) for the Virginia State Capitol. Beginning in 1895 Piccirilli sculpted a number of idealized mythological and allegorical figures. A series entitled *Joy of Life*, which he began about 1898, are examples of this more intimate work. The group originally included two marble figures modeled in 1898, each about fifty-six inches high. One of the two has

not been located and is known only from photographic documentation. The other was destroyed in a fire while being exhibited in 1920. A third, smaller version was likely carved by Piccirilli to replace the destroyed figure. In 1902, one of the marbles earned Piccirilli a silver medal at the South Carolina Interstate and West Indian Exposition, in Charleston. There are two known bronze copies made from an original marble, probably sand-cast from the plaster used to carve the marble. One is in the Virginia state collection, and the other is in a private collection in Florida. The statues, which have also been called *The Young Faun's Toilet* and *Young Faun*, represent a nude adolescent boy looking downward, in a contrapposto stance, with his arms raised to his head. They are elegantly simple and meditative works of art.[2]

Joy of Life came to Virginia's collection under unusual circumstances. Piccirilli was in Richmond on 10 November 1931 for the unveiling of his bust of Monroe in the Capitol. After the ceremony, Governor John Garland Pollard and his wife, Grace Phillips Pollard, entertained him at the Executive Mansion. Grace Pollard shared with the artist her desire to leave a gift to the Commonwealth, which was a tradition for governors' wives, but she was unable to do so because her serious illness had depleted the family's finances. Piccirilli was impressed by Mrs. Pollard, and after he returned to New York Piccirilli shipped *Joy of Life* to her for the Executive Mansion garden that she was planning. The statue arrived with a friendly letter, a drawing of a proposed stone base, and a photograph of the marble original.[3]

Governor Pollard wrote to the artist on 2 May 1932 to report that Piccirilli's gift to his wife "was received by Mrs. Pollard just before she became unconscious. I am sure that it will be gratifying to you to know how much joy your letter and gift gave her. The doctors tell me she is gradually losing strength, and that the end is near. She gave directions as to the placing of the statue and the

planting around it." Grace Pollard died on 4 May 1932, one day after the sculpture was installed.[4]

Joy of Life has been displayed continuously in the gardens of the Executive Mansion since 1932. In the spring of 2001 it was restored and is now the centerpiece of the north garden.

<div align="center">

TLK

</div>

NOTES

1. Josef Vincent Lombardo, *Attilio Piccirilli: Life of an American Sculptor* (New York: Pitman Publishing Corporation, 1944), especially 15, 17, 39, 41, 54–55; Janis Conner and Joel Rosenkranz, *Rediscoveries in American Sculpture: Studio Works, 1893–1939* (Austin: University of Texas Press, 1989), 143–150.

2. Conner and Rosenkranz, *Rediscoveries in American Sculpture*, 145; Lombardo, *Attilio Piccirilli*, 58; Adeline Adams, "A Family of Sculptors," *The American Magazine of Art* 12, no. 7 (July 1921): 230; Joel Rosenkranz, telephone interview with author, 5 November 2004. Rosenkranz indicated that the other bronze is in a private collection and like Virginia's also has no foundry mark. There is no record of who cast the bronzes.

3. Theodore Fred Kuper to John Garland Pollard, 14 April 1932, Virginia, Governor (1930–1934: Pollard), Executive Papers, 1930–1934, Accession 23344a, State Government Records Collection, The Library of Virginia, Richmond.

4. Pollard to Piccirilli, 2 May 1932, in ibid.

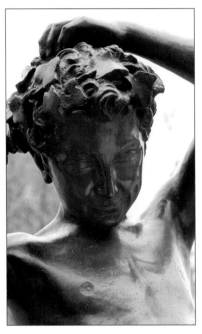

REFERENCES

Adams, Adeline. "A Family of Sculptors." *The American Magazine of Art* 12, no. 7 (July 1921): 223–230.

Conner, Janis, and Joel Rosenkranz. *Rediscoveries in American Sculpture: Studio Works, 1893–1939*. Austin: University of Texas Press, 1989.

Lombardo, Josef Vincent. *Attilio Piccirilli: Life of an American Sculptor*. New York: Pitman Publishing Corporation, 1944.

Piccirilli correspondence with Grace Phillips Pollard and John Garland Pollard. Virginia. Governor (1930–1934: Pollard). Executive Papers, 1930–1934. Accession 23344a. State Government Records Collection, The Library of Virginia, Richmond.

Shelley, Mary, and Bill Carroll. "The Piccirilli Studio." *Bronx County Historical Society Journal* 36 (Spring 1999): 1–12.

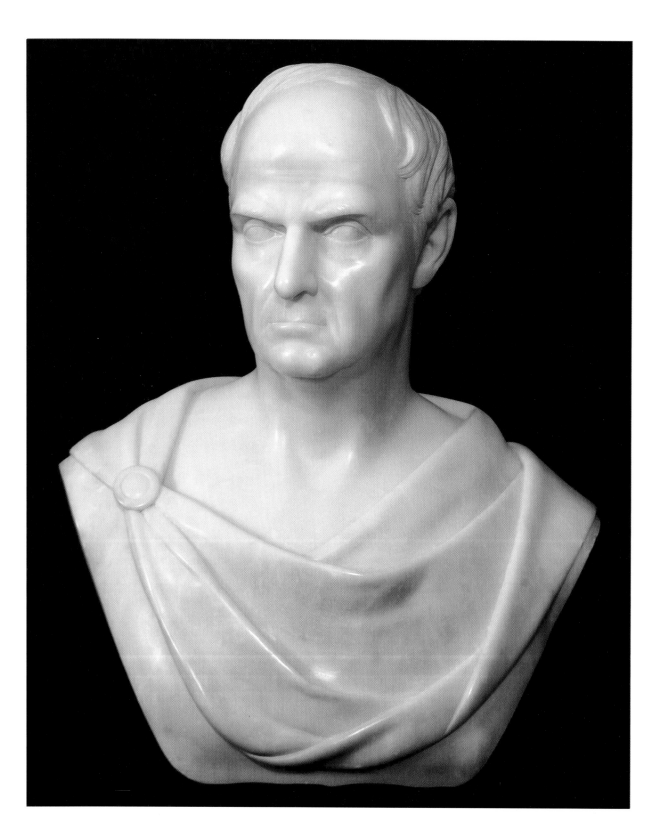

HIRAM POWERS (1805–1873)
DANIEL WEBSTER (1782–1852)

After 1853
Marble
Height 24¾ inches
Collection of the Library of Virginia, gift of Mariah
Louise (Mrs. William W.) Davies

Hiram Powers was born on a farm in Woodstock, Vermont, on 29 July 1805. As a young man he worked at several jobs in Cincinnati, Ohio, where his brother published a newspaper. He showed remarkable gifts for mechanical devices but eventually found his career when he began to study with Frederick Eckstein, a Prussian sculptor. In 1828 Powers left Cincinnati to further his artistic education. Six years later Powers moved to Washington, D.C., where he hoped to carve busts of the country's leaders to raise funds to travel to Italy, the prime destination for aspiring sculptors of the day. He was quickly in demand and even carved a bust of President Andrew Jackson, who sat for him at the White House in 1835. He also modeled busts of other prominent figures, including John Marshall, Martin Van Buren, John Quincy Adams, and John C. Calhoun. In the summer of 1836, after meeting with repeated evasions of his requests to model Massachusetts senator Daniel Webster, Powers was finally able to visit Webster at the senator's home in Marshfield, Massachusetts.[1]

This early bust of Webster is a powerful and noble likeness that captures both the facial features and the character of the man—in this case, someone Powers considered to be "the greatest man living." He described Webster as "the largest man I had ever seen. . . . It was not the mere pounds of human flesh that made Mr. Webster appear so very large—it was the great soul which we saw, looking out from eyes one third larger than I ever saw in any human head, and from under brows which, had I not seen them, I should have denied impossible." Created on speculation, Powers carved two marble versions of the bust, one in 1839 that was later purchased by the Boston Athenaeum and another acquired in 1852 by Duncan N. Hennen.[2]

With the support of several financial backers, Powers moved to Florence, Italy, in the autumn of 1837 to gain additional experience in carving marble and to expand his reputation. Another American artist, Horatio Greenough, supported him and helped the Powers family get settled. Powers worked on several commissioned portraits and idealized figures. The statue that established him as a major sculptor was the *Greek Slave*, which he exhibited in London in 1845. Powers hoped that the representation of a shackled, nude woman bound for the slave market in Constantinople would increase American sympathy for the Greeks who were engaged in a struggle for independence from Turkey. Important and controversial, the figure was one of the first American nudes to gain acceptance.[3]

Based on the success of the Webster bust, Powers accepted a commission in 1853 from the city of Boston to create a full-length bronze statue of the late orator, who died in 1852. To model the statue, Powers used the earlier bust, Webster's death mask, a daguerreotype, and a suit of clothes. The completed statue was sent by ship in August 1857 but was lost at sea. A second cast arrived in Boston in 1859 and was installed on the grounds of the Massachusetts State House. Unlike the earlier bust, the monumental statue depicts an older Webster dressed in contemporary clothing. He stands as if in a moment of contemplation before speaking, with his left hand resting on a fasces and his right hand holding a scroll. Despite critical reviews, the likeness received praise. Comparing the statue to the bust, an admirer wrote, "The bronze face is as good every where as the marble bust of Powers, from which it is copied, and is better in some respects,—indicating that Mr. Powers has profited by criticism." After a career that included the sculpting of fourteen full-length statues and more than one hundred busts, Hiram Powers died in Florence, Italy, on 27 June 1873. The contents of his studio now belong to the Smithsonian Institution.[4]

Born on 18 January 1782 in Salisbury, New Hampshire, Daniel Webster was graduated from Dartmouth College in 1801, then studied law with two attorneys, and began his legal practice in 1804. He was elected twice to the United States House of

Representatives from New Hampshire, in 1812 and 1814, becoming an influential member and an opponent of the War of 1812. He moved to Massachusetts in 1816, by which time he was one of the foremost attorneys in the United States. He argued more important cases before the Supreme Court of the United States than any other advocate of his day. Webster served in the House of Representatives from Massachusetts from 1822 to 1827, when he was elected to the United States Senate. One of the great orators in Congress, Webster was also a national leader in the Whig Party and ambitious to be elected president. He was a candidate in 1836 when Powers first modeled his face. Webster served in the Senate until 1841, when President William Henry Harrison appointed him secretary of state. Webster served until 1843. Elected to the Senate again in 1845, he became secretary of state a second time in the summer of 1850 and still held the office when he died in Marshfield, Massachusetts, on 24 October 1852. In 1860 the Virginia General Assembly created Webster County in his honor, one of the counties that three years later became part of West Virginia.[5]

The Library of Virginia's marble bust of Daniel Webster was carved probably from the model that the artist used for the bronze statue in the 1850s. It shows an older man, a little puffier and less vigorous than in earlier portraits, but still possessing powerful nobility. It is interesting to note that this bust wears a toga, whereas the first bust is nude and the statue is clothed in contemporary garb. It is possible that the sculptor felt freer to follow his own neoclassical taste when making copies from the commissioned portrait. The Library of Virginia acquired the bust in 1908 from Mariah Louise Davies, of Richmond.

TLK

NOTES

1. Brian L. Meggitt, "Powers, Hiram," *American National Biography* (New York and Oxford, Eng.: Oxford University Press, 1999), 17:793–794; Sylvia E. Crane, *White Silence: Greenough, Powers, and Crawford, American Sculptors in*

Nineteenth-Century Italy (Coral Gables, Fla.: University of Miami Press, 1972), 169–174. See also *Volume I: Life,* in Richard P. Wunder, *Hiram Powers: Vermont Sculptor, 1805–1873,* 2 vols. (Newark: University of Delaware Press, 1991).

2. Hiram Powers to Hamilton Fish, 17 November 1859, quoted in Wunder, *Hiram Powers* 1:92; for disposition of busts, see *Hiram Powers,* 2:105.

3. Wayne Craven, *Sculpture in America* (New York: Thomas Y. Crowell Company, 1968), 116–119.

4. Wunder, *Hiram Powers,* 1:282–284, 307–308, 354 n. 36; Theophilus Parsons to Edward Everett, 6 June 1859, quoted in Edward Everett, *Defence of Powers' Statue of Webster* (Boston: William White, Printer, 1859), 14; James Barber and Frederick Voss, *The Godlike Black Dan: A Selection of Portraits from Life in Commemoration of the Two Hundredth Anniversary of the Birth of Daniel Webster* (Washington: Published for the National Portrait Gallery by the Smithsonian Institution Press, 1982), 38–39; Emily J. Salmon and Edward D. C. Campbell Jr., eds., *The Hornbook of Virginia History: A Ready-Reference Guide to the Old Dominion's People, Places, and Past,* 4th ed. (Richmond: The Library of Virginia, 1994), 47, 177.

5. Maurice G. Baxter, "Webster, Daniel," *American National Biography* (New York and Oxford, Eng.: Oxford University Press, 1999), 22:865–868.

REFERENCES

Barber, James, and Frederick Voss. *The Godlike Black Dan: A Selection of Portraits from Life in Commemoration of the Two Hundredth Anniversary of the Birth of Daniel Webster.* Washington: Published for the National Portrait Gallery by the Smithsonian Institution Press, 1982.

Baxter, Maurice G. "Webster, Daniel." *American National Biography,* 22:865–868. New York and Oxford, Eng.: Oxford University Press, 1999.

Crane, Sylvia E. *White Silence: Greenough, Powers, and Crawford, American Sculptors in Nineteenth-Century Italy*. Coral Gables, Fla.: University of Miami Press, 1972.

Everett, Edward. *Defence of Powers' Statue of Webster*. Boston: William White, Printer, 1859.

Meggitt, Brian L. "Powers, Hiram." *American National Biography*, 17:793–794. New York and Oxford, Eng.: Oxford University Press, 1999.

Remini, Robert V. *Daniel Webster: The Man and His Time*. New York: W. W. Norton, 1997.

Wunder, Richard P. *Hiram Powers: Vermont Sculptor, 1805–1873*. 2 vols. Newark: University of Delaware Press, 1991.

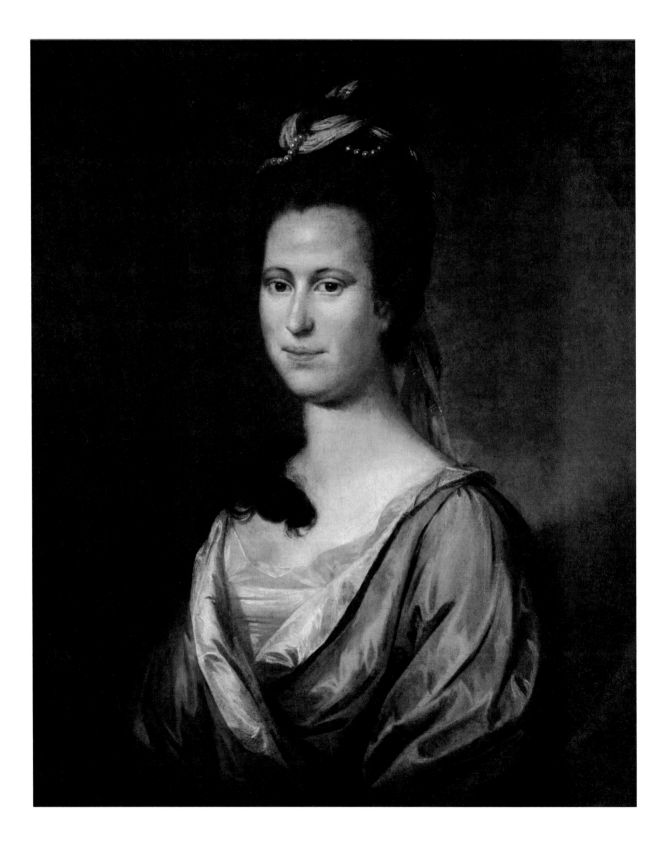

MATTHEW PRATT (1734–1805)
MARY WILLING BYRD (1740–1814)

Ca. 1773
Oil on canvas
30¼ inches x 25⅝ inches
Collection of the Library of Virginia, gift of Maria Byrd
Hopkins Wright

Born in Philadelphia on 23 September 1734, Matthew Pratt was apprenticed at age fifteen to his uncle James Claypoole Sr., "Limner and Painter in general." After leaving his nearly seven-year apprenticeship in 1755, Pratt embarked on several business ventures before settling on portrait painting and opening a studio in Philadelphia in 1758. In the summer of 1764 he went to England with his cousin, who was engaged to marry American expatriate artist Benjamin West. Pratt stayed in England and became West's first pupil, studying with him for two and a half years. In 1765 Pratt painted his best-known work, *The American School*, a popular conversation piece that portrayed West in his studio, teaching Pratt and three other students. After almost four years in Europe, Pratt returned to Philadelphia in 1768 and readily earned commissions from the city's leading families. Three years later, while in New York, Pratt met the artist John Singleton Copley and was greatly impressed by his work.[1]

Pratt stayed for a time in Williamsburg, Virginia, in the spring of 1773 and took out three advertisements in the *Virginia Gazette*. On 4 March he offered "a small but very neat Collection of PAINTINGS, which are now exhibiting at Mrs. VOBE's, near the Capitol," which included copies of portraits by West and Old Masters. Little else is known about Pratt's activities in Virginia aside from several identified portraits, but he apparently received enough commissions to extend his stay longer than originally planned. His advertisement of 18 March announced that "it is likely Mr. *Pratt* will continue some Time in this Colony, if any Gentlemen or Ladies are desirous to employ him . . . he will endeavor to wait on them on his Way down from the Place where he is at present employed, near *Richmond*, as he intends to spend the Summer Months at *Hampton*." After returning to Philadelphia, Pratt continued to paint portraits, but with the start of the American Revolution his career suffered. To supplement his income, he opened a drawing school and painted shop-signs. Matthew Pratt died in his native city on 9 January 1805.[2]

It is likely that the portrait of Mary Willing Byrd was painted about the time Pratt announced that he was staying near Richmond. Born in Philadelphia on 10 September 1740, she became the second wife of William Byrd (1728–1777) on 29 January 1761. A year later they moved to Westover, on the James River between Richmond and Williamsburg. She became a widow early in 1777 when her husband, burdened with debt and distraught over politics, killed himself. She is known for being amiable, yet vigilant—managing to care for her eight surviving children, to pay off her husband's debts, and to hold on to the family estate during and after the Revolution.[3]

This colorful painting is a good example of Pratt's charming interpretations of fashionable eighteenth-century European portraits. In comparison to the styles of Continental artists like West or Joshua Reynolds, Pratt's portraits have a slight stiffness, but to Pratt's credit, the sitters appear genuine and earthbound instead of clumsy. The format of this portrait is typical of Pratt's work, a bust-length, three-quarter view, with painted corner spandrels and a spare background. It is also painted in his signature palette. The overall effect is simple and elegant. The influence of Copley's work is visible in Pratt's portraits of this period, which exhibit an increased sculptural quality in the rendering of the body, particularly in the face.[4]

It is likely that William Byrd commissioned this portrait of his wife for display at Westover. When she prepared her will about a year before her death in March 1814, Mary Willing Byrd bequeathed a portrait of herself, which might have been this one, to her daughter, Maria H. Byrd Page. One of Mary Willing Byrd's descendants,

Maria Byrd Hopkins Wright, donated the portrait to the Library of Virginia in February 1920.[5]

TLK

NOTES

1. Charles Henry Hart, ed., "Autobiographical Notes of Matthew Pratt, Painter," *Pennsylvania Magazine of History and Biography* 19 (1896): 460–467 (quotation on 460); William Sawitzky, *Matthew Pratt, 1734–1805* (New York: The New-York Historical Society in Cooperation with the Carnegie Corporation of New York, 1942), 9–11; "Matthew Pratt, 1734–1805," in John Caldwell and Oswaldo Rodriguez Roque, with Dale T. Johnson, *American Paintings in the Metropolitan Museum of Art*, vol. 1, *A Catalogue of Works by Artists Born by 1815*, ed. Kathleen Luhrs (New York: The Metropolitan Museum of Art in Association with Princeton University Press, 1980), 55–63.

2. *Virginia Gazette* (Williamsburg: Alexander Purdie and John Dixon), 4 March 1773 (1st quotation); *Virginia Gazette* (Williamsburg: Alexander Purdie and John Dixon), 18 March 1773 (2d quotation); Sawitzky, *Matthew Pratt*, 29–31; Susan Rather, "Pratt, Matthew," *American National Biography* (New York and Oxford, Eng.: Oxford University Press, 1999), 17:815–816.

3. Sara B. Bearss, "Byrd, Mary Willing," *Dictionary of Virginia Biography* (Richmond: The Library of Virginia, 2001), 2:457–459.

4. Sawitzky, *Matthew Pratt*, 12.

5. "The Will of Mrs. Mary Willing Byrd, of Westover, 1813, with a List of the Westover Portraits," *Virginia Magazine of History and Biography* 6 (1899): 349.

REFERENCES

Arthur, Mildred H. "The Widow of Westover and Women's Rights." *Colonial Williamsburg* 12 (Summer 1990): 28–34.

Bearss, Sara B. "Byrd, Mary Willing." *Dictionary of Virginia Biography*, 2:457–459. Richmond: The Library of Virginia, 2001.

Hart, Charles Henry, ed. "Autobiographical Notes of Matthew Pratt, Painter." *Pennsylvania Magazine of History and Biography* 19 (1896): 460–467.

"Matthew Pratt, 1734–1805." In John Caldwell and Oswaldo Rodriguez Roque, with Dale T. Johnson. *American Paintings in the Metropolitan Museum of Art*, vol. 1, *A Catalogue of Works by Artists Born by 1815*. Edited by Kathleen Luhrs, 55–63. New York: The Metropolitan Museum of Art in Association with Princeton University Press, 1980.

Rather, Susan. "Pratt, Matthew." *American National Biography*, 17:815–816. New York and Oxford, Eng.: Oxford University Press, 1999.

Sawitzky, William. *Matthew Pratt, 1734–1805*. New York: The New-York Historical Society in Cooperation with the Carnegie Corporation of New York, 1942.

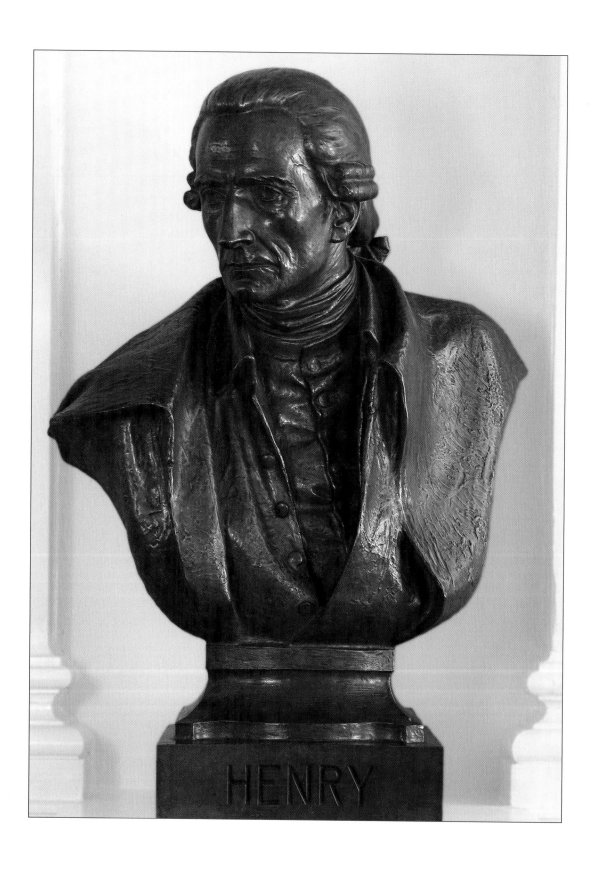

FREDERICK WILLIAM SIEVERS (1872–1966)
PATRICK HENRY (1736–1799)

1932
Bronze
Height 36¾ inches
Inscribed on back "F. Wᵐ SIEVERS, Sc. / 1932"
Collection of the Commonwealth of Virginia, gift of John Henry Miller

Often referred to as the "Sculptor to the Confederacy," Frederick William Sievers was born in Fort Wayne, Indiana, on 26 October 1872. His father's job as a traveling salesman required frequent moves until the family finally settled in Atlanta, Georgia, when William was about fifteen. There he received his first artistic education as an apprentice to a woodcarver. In 1892 or 1893, the family moved to Richmond, where he stayed for about seven years, carving picture frames and taking evening classes at the Virginia Mechanic's Institute, where he studied modeling with sculptor Frederick Moynihan. Sievers aspired to more conventional artistic study in Europe, however, and earned money toward his dream by selling carved furniture. In July 1898 Sievers moved to Rome, a destination long attractive to aspiring sculptors because of the abundance of ancient models and availability of solid artistic training. He was admitted to the Regio Istituto di Belle Arti after taking classes in the evening *liceo artistico* (artistic secondary school) to qualify for admission to the institute. After returning to the United States in 1902, Sievers studied in the studio of Karl Bitter, of Hoboken, New Jersey. Living near New York provided Sievers the opportunity to meet many established sculptors, among them Daniel Chester French, and Sievers was inspired to open his own studio there in 1905. It was probably a combination of the competition in New York and an increasing number of southern monument commissions that encouraged Sievers to return to Richmond in 1910.[1]

Sievers is best known for the monuments he created in the South. The first few statues he made in Virginia were collaborative efforts; Sievers modeled the designs of another Richmonder, painter William Ludwell Sheppard. Their productions include the bronze statue of Governor William "Extra Billy" Smith in Capitol Square. Sievers's most famous piece is the *Virginia Monument* at Gettysburg National Military Park, dedicated to the memory of Virginia's soldiers who participated in the battles on that

site in July 1863. He also created several other well-known monuments in Richmond, including the popular bronze equestrian statue of Lieutenant General Thomas J. "Stonewall" Jackson and the seated figure of Matthew Fontaine Maury, both on Monument Avenue. Commissioned to sculpt several busts for the Virginia Capitol, Sievers created a bronze of Sam Houston and a marble bust each of Presidents James Madison and Zachary Taylor. Sievers's last public work was the *Confederate Soldiers Monument* unveiled in 1937 at the Woodlawn National Cemetery in Elmira, New York. Frederick William Sievers died in Richmond on 5 July 1966.[2]

In 1932, Sievers executed a bronze bust of the Commonwealth's first governor, Patrick Henry, for the Capitol, one of about a dozen likenesses of great antebellum Virginians commissioned for the old chamber of the House of Delegates. The bust is a commanding and unusual piece, exhibiting to dramatic effect the artist's unique style—a distinctive combination of academic naturalism, reinvigorated with a strong sense of energy. Henry's gaze looks downward, and he is leaning slightly forward, as if deep in thought and about to launch into speech. The larger-than-life-size scale creates an arresting effect, and the dramatic asymmetrical cropping of the clothing adds to the sense of vigor.

Patrick Henry would certainly be on everyone's list of great Virginians. Born on 29 May 1736 in Hanover County, he studied law and was admitted to the bar in 1760. In 1763, he earned a reputation as a powerful speaker when he argued for the assembly's power in the celebrated Parsons' Cause. In 1765 Henry was elected to the House of Burgesses, where he persuaded the House to adopt extremely strong resolutions condemning the Stamp Act of that year. A spellbinding orator, Henry is most remembered for a passionate speech made during the second Revolutionary convention in Richmond on 23 March 1775, when he persuaded the convention to place the

colony in a posture of defense against the British. Henry's concluding words are among the most famous in American history: "Is life so dear, or peace so sweet, as to be purchased at the price of chains and slavery? Forbid it, Almighty God!—I know not what course others may take; but as for me, give me liberty, or give me death!"[3]

Henry was a Virginia delegate to the Continental Congress in 1774 and 1775 and was the first governor of the independent Commonwealth of Virginia from 6 July 1776 to 1 June 1779. He was governor again from 30 November 1784 to 30 November 1786 and was frequently a member of the House of Delegates when not governor. He was one of the most influential opponents of ratification of the Constitution of the United States at the June 1788 Virginia convention. The greatest orator of his time, Patrick Henry died at his home Red Hill, in Charlotte County, on 6 June 1799.[4]

The bronze bust, cast by the Gorham Company, was unveiled in the Capitol on 29 November 1932, a gift to the Commonwealth by John Henry Miller, a descendant of the orator.[5]

TLK

NOTES

1. Ulrich Troubetzkoy, "F. William Sievers, Sculptor," *Virginia Cavalcade* 12 (Autumn 1962): 4–7; Leslie A. Przybylek, "Soldiers to Science: Changing Commemorative Ideals in the Public Sculpture of Frederick William Sievers" (Master of Arts thesis, University of Delaware, 1995), 5–9; Frederick William Sievers Papers, 1902–1969, Accession 33604, Personal Papers Collection, The Library of Virginia, Richmond.

2. Troubetzkoy, "F. William Sievers, Sculptor," 7–12; Przybylek, "Soldiers to Science," 14–15, 23 n. 48.

3. Thad Tate, "Henry, Patrick," *American National Biography* (New York and Oxford, Eng.: Oxford University Press, 1999), 10:615–617; William Wirt, *Sketches of the Life*

and Character of Patrick Henry, rev. ed. (Ithaca, N.Y.: Mack, Andrus & Co., 1848), 94–95 (quotation).

4. Tate, "Henry, Patrick," 617–618.

5. *Ceremonies, Unveiling of the Bust of Patrick Henry, Old Hall of the House of Delegates, State Capitol, Richmond, Virginia, Tuesday, November 29, 1932, 3:30 o'clock, P.M.* (Richmond: N.p., 1932). The original plaster bust used to cast the bronze is owned by the Association for the Preservation of Virginia Antiquities and is on display at Scotchtown, Henry's home in Hanover County. The APVA acquired the plaster bust from Sievers.

REFERENCES

Beeman, Richard R. *Patrick Henry: A Biography*. New York: McGraw-Hill, 1974.

Mayer, Henry. *A Son of Thunder: Patrick Henry and the American Republic*. New York: F. Watts, 1986.

Przybylek, Leslie A. "Soldiers to Science: Changing Commemorative Ideals in the Public Sculpture of Frederick William Sievers." Master of Arts thesis, University of Delaware, 1995.

Sievers, Frederick William. Papers, 1902–1969. Accession 33604. Personal Papers Collection, The Library of Virginia, Richmond.

Tate, Thad. "Henry, Patrick." *American National Biography*, 10:615–619. New York and Oxford, Eng.: Oxford University Press, 1999.

Troubetzkoy, Ulrich. "F. William Sievers, Sculptor." *Virginia Cavalcade* 12 (Autumn 1962): 4–12.

S<small>IEVERS IN HIS STUDIO, WITH MODEL FOR</small> *Patrick Henry*, <small>CA.</small> 1932

WILLIAM THOMPSON RUSSELL SMITH (1812–1896) JACKSONS RIVER, VIRGINIA

1848
Oil on wood panel
18 inches x 13¾ inches
Inscribed on reverse "Jacksons River Va. / Russell Smith / 1848"
Collection of the Executive Mansion, gift of Dr. and Mrs. Thomas Summey

William Thompson Russell Smith, born in Glasgow, Scotland, on 26 April 1812, immigrated to the United States in 1819. He studied with James Reid Lambdin, an artist and proprietor of the Pittsburgh Museum, from 1829 to 1832 and began a long association with theater manager Francis Courtney Wemyss in 1833. He developed into a popular and successful scenery painter. Early in the 1840s, Smith produced illustrations for scientific lecturers, including Sir Charles Lyell and Benjamin Silliman. He worked as a field artist for the geological survey that William Barton Rogers conducted in Virginia in 1844 and for a similar expedition along the Juniata and Susquehanna Rivers in Pennsylvania that Henry D. Rogers led the following year. Smith was successful enough to take his wife and two children to Europe in 1851. Returning to the United States in 1852, he continued to work as a scenery painter for theaters in Boston, Philadelphia, Baltimore, Brooklyn, and Washington, D.C. Smith exhibited regularly in Philadelphia at the Pennsylvania Academy of the Fine Arts and at the Artists' Fund Society; in New York at the National Academy of Design, the American Art-Union, and the Apollo Association; and at the Boston Athenaeum.[1]

Both of Smith's children, Xanthus (1839–1929) and Mary (1842–1878), became artists. The year after his daughter died, Smith established a prize at the Pennsylvania Academy of the Fine Arts to be awarded to a resident woman artist who exhibited in the academy's annual exhibition of oil paintings. William Thompson Russell Smith died on 8 November 1896 at his home in Pennsylvania.[2]

Henry Tuckerman, an early chronicler of American artists, praised Smith for his "deep love of nature leading to simplicity and force of color and limning." Smith was part of a group of landscape painters who generally lacked European artistic training and focused on American subjects. In an 1877 article published in the *North American Review*, the writer extolled the virtues of these artists who were active before the Civil War. "Our artists," wrote the editor,

> discovered that they could learn more from the woods and the rivers and the bays of their own country than could be taught them by all the painters of Munich, Rome, or Paris. . . . The demand for home scenes, scenes in which the people moved and lived, was constantly increasing, and marked an epoch in American art. It called forth such painters as Kensett, Whittredge, Russell Smith, Hubbard, S. R. Gifford, Church, Inness, Cole, Coleman, and others. . . . This entire school of landscape-painters is the product of the public taste as it existed before the war. The public mind was in greater repose, less cosmopolitan.[3]

During the summer of 1844, Smith and William Barton Rogers set out on a journey to complete a survey of the geology of Virginia, a project on which Rogers had been working for several years. The Virginia General Assembly authorized the geological survey by an act passed on 26 February 1836. The assembly supported the survey each year until an economic recession in 1842 ended funding. In 1844 Rogers hired Smith to make drawings of the landscape that were to illustrate his final report. As Rogers studied and lectured on the geology of the state, Smith sketched the landscape. Traveling to Richmond, Smith recorded in his journal his initial disappointment in the scenery. "Everything shows a want of intelect—fences, grass, ploughing and houses." His impression of Virginia changed as he and Rogers traveled throughout the rest of the state, and the University of Virginia particularly impressed him. Rogers took Smith a few miles west of Charlottesville at sunset, where Smith recorded that he "was forcibly struck with superior picturesque beauty of the Blue Ridge to any of the Penna. Mountains."[4]

Because the government never appropriated money to complete and publish the report, Rogers retained his records of the survey until his death in 1882. His widow, Emma Savage Rogers, presented some of the papers to the Virginia State Library in 1900 and the remainder in 1903. Fifty-one of Smith's sketches are included in the collection. Using his drawings, which frequently included notes about color and light, Smith later executed a number of oil paintings of the Virginia landscape. In 1849 he exhibited, among other works, a landscape of a scene on the Jackson River, which flows south southwest out of Highland County through Bath County and into Alleghany County, where it joins the Cowpasture River to form the James River.[5]

Dr. and Mrs. Thomas Summey donated *Jacksons River, Virginia* to the Executive Mansion in 1976.

BCB

REFERENCES

Ferrante, Anne. "Early Photographic Images of the Smiths: A Family of Artists." *Archives of American Art Journal* 21 (1981): 18–23.

Lewis, Virginia E. *Russell Smith, Romantic Realist.* Pittsburgh: University of Pittsburgh Press, 1956.

Torchia, Robert W., and David B. Rowland. *The Smith Family Painters: A Series of Exhibitions.* Collegeville, Pa.: Philip and Muriel Berman Museum of Art, Ursinus College, 1998.

NOTES

1. Virginia E. Lewis, *Russell Smith, Romantic Realist* (Pittsburgh: University of Pittsburgh Press, 1956), 95–96; Anne Ferrante, "Early Photographic Images of the Smiths: A Family of Artists," *Archives of American Art Journal* 21 (1981): 18–23; Robert W. Torchia and David B. Rowland, *The Smith Family Painters: A Series of Exhibitions* (Collegeville, Pa.: Philip and Muriel Berman Museum of Art, Ursinus College, 1998), 5–10.

2. Torchia and Rowland, *Smith Family Painters*, 11.

3. Henry Tuckerman, *Book of the Artists: American Artist Life* (New York: G. P. Putnam & Son, 1867), 519; The Editor, "The Progress of Painting in America," *North American Review* 124 (1877): 456.

4. Smith's journal quoted in Lewis, *Russell Smith*, 96, 98.

5. Records of the Rogers survey are split between the Board of Public Works Collection (Geological Survey Records, 1837–1853, BPW 21), and Virginia Geological Survey, Records, 1834–1903, Accession 24815, State Government Records Collection, The Library of Virginia, Richmond.

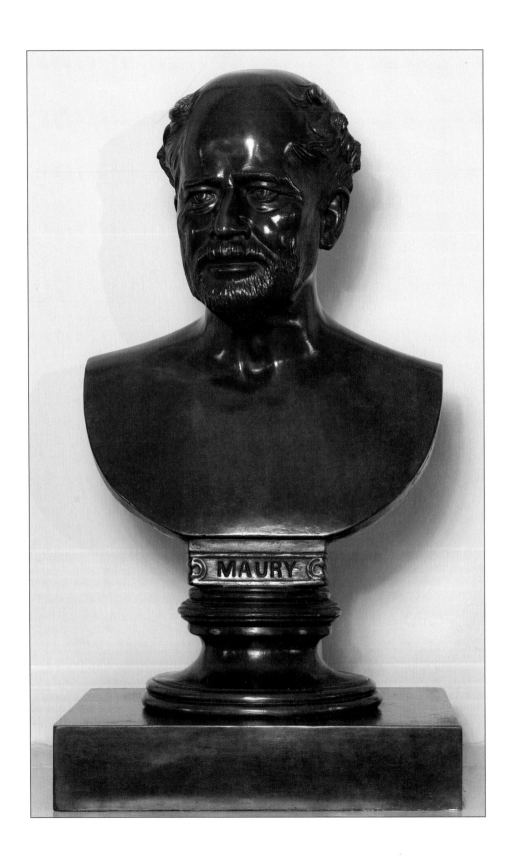

EDWARD VIRGINIUS VALENTINE
(1838–1930)
MATTHEW FONTAINE MAURY
(1806–1873)

1869
Bronze
Height 24½ inches
Inscribed under proper left shoulder "Edward V. Valentine"
Inscribed on front "MAURY"
Collection of the Commonwealth of Virginia, gift of
Alice Maury Parmelee

The youngest of nine children, Edward Virginius Valentine was born on 12 November 1838 into a Richmond merchant family that socialized with artists and writers. One of his brothers was a close friend of the artist William James Hubard and knew the sculptor Horatio Greenough as well. Valentine showed an early talent for drawing and studied with Hubard and with Edward F. Peticolas and Oswald Heinrich; he later studied anatomy at the Medical College of Virginia. In 1853 he visited the Exhibition of the Industry of All Nations in New York, where he saw the monumental sculpture *Amazon Attacked by a Tiger*, by August Kiss, of Berlin. Enthralled, Valentine decided to become a sculptor. In April 1859 he sailed for Europe, where for six years he traveled in France, Italy, and Germany. After studying with Thomas Couture and François Jouffroy in Paris and Raffaello Buonajuti in Florence, Valentine settled in Berlin to study with Kiss. In March 1865, Kiss died, and in June of that year Valentine's father died. Valentine returned to Richmond, where he worked for the remainder of his life.[1]

With support from his family, Valentine opened a studio and used his family's business connections to meet prospective subjects or patrons. He worked in clay and then had a plaster mold made from which he could cast copies for sale. Valentine realized the value of photography and thus had completed works photographed as cartes-de-visite to be slipped into letters to friends and acquaintances who might help him receive commissions. He also sent the photographs to merchants in Washington, D.C., Cincinnati, Philadelphia, and Boston, asking them to display the images in their windows.[2]

In 1870 Valentine received permission to visit Robert E. Lee, then-president of Washington College, in Lexington, to take measurements for a bust. Valentine modeled and cast the bust and was preparing to send it to

Lexington when he received word of the general's death. Valentine sent the cast to the general's widow, Mary Custis Lee, who pronounced the likeness accurate. With her endorsement and encouragement, the Rockbridge Memorial Association commissioned Valentine to create the memorial sarcophagus for the mausoleum in which the association planned to inter the general. The resulting marble work, *Recumbent Lee*, installed in the Lee Chapel at Washington and Lee College in 1883, made Valentine's reputation.[3]

In a fifty-year career, Valentine sculpted numerous portrait busts, genre pieces of African Americans, ideal figures, and monumental statues. He executed busts of several famous Confederate military leaders and made portrait busts of writers and educational leaders. His monumental works include statues of Jefferson Davis and Williams Carter Wickham in Richmond, of Hugh Mercer in Fredericksburg, and of John James Audubon in New Orleans. The Virginia state art collection includes Valentine's busts of Robert Burns, William Wirt Henry, Albert Sidney Johnston, Joseph Eggleston Johnston, William "Extra Billy" Smith, Thomas Joynes, and James Ewell Brown Stuart, along with two busts of Matthew Fontaine Maury. Edward Virginius Valentine died in Richmond on 19 October 1930.[4]

Always interested in history, Valentine kept daily diaries, intending to write a history of Richmond, and following the death of his brother, Mann Valentine, in 1892, he helped his nephews catalog Mann's collection of archaeological and historical materials. He was the first president of the Valentine Museum, which opened in 1898, and he left his work, furniture, memorabilia, and papers to the museum. Valentine's studio, at 809 East Leigh Street, was rescued from destruction in 1936 and moved to the garden behind the Valentine Museum. In

2002–2003, the museum renovated the studio and installed the sculpture with interpretation to preserve Valentine's place in American art.[5]

Matthew Fontaine Maury was born on 14 January 1806 near Fredericksburg. He joined the United States Navy and made three extended voyages to Europe, the Pacific coast of South America, and around the world between 1825 and 1834. He then returned to Fredericksburg. A stagecoach accident ended Maury's seagoing expeditions, so he began to publish works on navigation. In 1842 he became superintendent of the Navy Department's Depot of Charts and Instruments (later the Naval Observatory), in Washington, D.C., and continued to write and publish research on oceanography and meteorology. In 1853 Maury represented the United States at an international congress in Brussels, where he advocated a standard system of recording oceanographic data aboard naval vessels and merchant marine ships. In 1855 he published *The Physical Geography of the Sea*, the first textbook of modern oceanography. Maury's accuracy enabled mariners to chart faster passages across the seas. His charts of ocean currents and winds were in great demand by mariners.[6]

With the outbreak of the Civil War, Maury resigned from the U.S. Navy and accepted a position with the navy of the Confederate States of America. He went to England on behalf of the Confederate government to acquire ships for the Confederacy. Maury also experimented with an electrical underwater torpedo mine. In 1868 he became a professor at the Virginia Military Institute, and that same year he published the *Physical Survey of Virginia*. Matthew Fontaine Maury died in Lexington on 1 February 1873 and was buried at Richmond's Hollywood Cemetery.[7]

Matthew Fontaine Maury sat for Valentine several times beginning on 5 February 1869, as the sculptor took measurements, sketched, and modeled Maury's head in clay. The bust was cast in plaster by Francesco Bernicchi, who received four dollars for making the cast. In a letter to the *Index and Baptist*, in Atlanta, an unnamed correspondent reported seeing the bust in Valentine's studio. He described it as "one of the most perfect likenesses I ever saw, bringing out, with the skill of a master, not simply the facial features, but the moral and intellectual characteristics of our world-renowned physical Geographer." In February 1873 the Virginia State Library acquired from Valentine a plaster cast

of the bust that the artist had painted bronze. Maury's son-in-law gave another copy to the Southern Society in New York City in 1890, and ten copies in bronze were commissioned in 1906. One of Maury's sons reserved four for himself on the condition that the remaining six be subscribed for by others.[8]

Alice Maury Parmelee, a granddaughter of Maury, gave a bronze cast of the bust to the State Capitol in 1932.[9]

BCB

NOTES

1. Margaret Junkin Preston, "Edward Virginius Valentine," *American Art Review* (1880): 277–282; Elizabeth Gray Valentine, *Dawn to Twilight: Work of Edward V. Valentine* (Richmond: William Byrd Press, 1929), 28, 43; Edward Virginius Valentine Papers, MS. C57, Valentine Richmond History Center.

2. For his use of photographs, see Valentine's correspondence in the Edward Virginius Valentine Papers, at the Valentine Richmond History Center.

3. Barbara C. Batson, "Valentine, Edward Virginius," *American National Biography* (New York and Oxford, Eng.: Oxford University Press, 1999), 22:137.

4. Valentine's great-niece, Elizabeth Gray Valentine, lists his sculptural works with their dates of modeling, casting, and installation in her laudatory biography *Dawn to Twilight*, 129–166. Valentine relied on her great-uncle's diaries to devise her list of his works.

5. Harry Kollatz Jr., "The Story of Ned's Shed: E. V. Valentine's Art Radiated from Richmond," *Richmond Magazine* (March 2002): 54–58, 74–76.

6. Norman J. W. Thrower, "Maury, Matthew Fontaine," *American National Biography* (New York and Oxford, Eng.: Oxford University Press, 1999), 14:743–744.

7. Ibid., 744.

8. Valentine, *Dawn to Twilight*, 136; Receipt dated 4 March 1869, Edward Virginius Valentine Papers; *Atlanta Index and Baptist*, 18 March 1869, clipping in Edward Virginius Valentine Papers (quotation); "The Late Commodore Maury," *Richmond Evening News*, 18 February 1873; "Pathfinder of the Seas," *Richmond Times*, 20 December 1890; "Will Reproduce Bust of Maury," unidentified newspaper clipping, 26 May 1906, Edward Virginius Valentine Papers.

9. "Bronze Bust of Maury Has Arrived at State Capitol," *Richmond News Leader*, 18 March 1932.

REFERENCES

Batson, Barbara C. "Valentine, Edward Virginius." *American National Biography*, 22:137–138. New York and Oxford, Eng.: Oxford University Press, 1999.

Hearn, Charles G. *Tracks in the Sea: Matthew Fontaine Maury and the Mapping of the Oceans*. Camden, Maine: International Marine/ McGraw-Hill, 2002.

Kollatz, Harry, Jr. "The Story of Ned's Shed: E. V. Valentine's Art Radiated from Richmond," *Richmond Magazine* (March 2002): 54–58, 74–76.

Preston, Margaret Junkin. "Edward Virginius Valentine." *American Art Review* (1881): 277–282.

Simms, L. Moody, Jr. "A Virginia Sculptor." *Virginia Cavalcade* 20 (Summer 1970): 20–27.

Thrower, Norman J. W. "Maury, Matthew Fontaine." *American National Biography*, 14:743–744. New York and Oxford, Eng.: Oxford University Press, 1999.

Valentine, Edward Virginius. Papers. MS. C57. Valentine Richmond History Center.

Valentine, Elizabeth Gray. *Dawn to Twilight: Work of Edward V. Valentine*. Richmond: William Byrd Press, 1929.

EDWARD V. VALENTINE IN HIS STUDIO, WITH MODEL FOR *Blind Girl*, CA. 1890. COURTESY OF THE VALENTINE RICHMOND HISTORY CENTER.

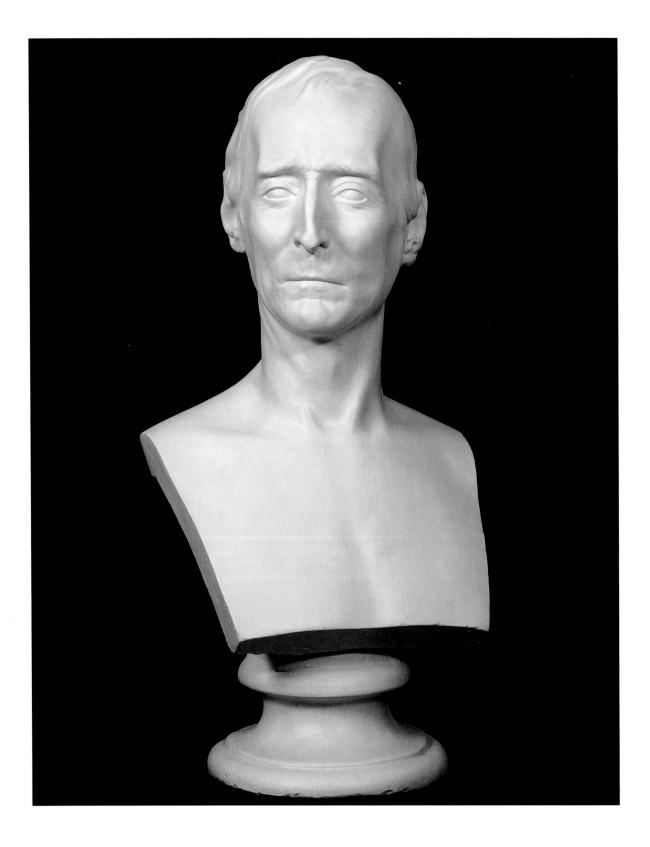

FREDERICK A. VOLCK
(CA. 1833–1891)
JOHN TYLER JR. (1790–1862)

1862
Painted plaster
Height 26½ inches
Inscribed on back of proper right shoulder "F. Volck.
1862"
Collection of the Library of Virginia

Little is known about sculptor Frederick Volck's early life. He was born in Nuremberg, Germany, perhaps in 1833. The 1860 federal census lists Volck as a sculptor who was living in Baltimore with his older brother Adalbert Volck, a physician, painter, and etcher. Early in the Civil War, Volck moved to Richmond, where he worked as a draftsman in the Office of Ordnance and Hydrography of the Confederate Navy Department, under the charge of John Mercer Brooke. He was also listed as a second sergeant in the Government Guard unit of the Virginia Local Defense, assigned to the protection of Richmond. While the body of Lieutenant General Thomas J. "Stonewall" Jackson lay in state in the Executive Mansion in Richmond in 1863, Volck made a death mask and took measurements of the body. During the war, Volck also made busts of Brooke and of Jefferson Davis, but both busts were reportedly destroyed during the evacuation fire in April 1865. The artist continued to work in Virginia until the war ended, but he returned to Baltimore sometime thereafter.[1]

By 1869, Volck was in Munich, where he sculpted a life-size statue of William Prescott Smith, of Baltimore, a railroad magnate and author of *The Book of the Great Railway Celebrations of 1857; Embracing a Full Account of the Opening of the Ohio & Mississippi, and the Marietta & Cincinnati Railroads, and the Northwestern Virginia Branch of the Baltimore and Ohio Railroad* (1858). Volck still had his studio in Munich in 1876 when he enlarged William H. Rinehart's eighteen-inch sculpture of Smith to full size to cast in bronze in Nuremburg that year. Volck was an exacting and careful sculptor, making measurements and models from life for his commissions. He went so far as to take measurements of Robert E. Lee's horse, Traveller, in order to be completely correct for an equestrian statue of the general, now at the New Market Battlefield State Historical Park. In 1901 a New Orleans donor presented the Virginia Military Institute with a life-size bronze bust

of Lee that Tiffany and Company had cast from the model that Volck had made. The *Washington Post* of 13 June 1901 reported that Frederick A. Volck had exhausted his finances while making the model and had died soon after, sometime in 1891.[2]

Volck's bust of John Tyler portrays an aged and drawn man at the end of a life of public service. Born on 29 March 1790 into a prominent family in Charles City County, Virginia, Tyler was the son of John Tyler (1747–1813), who was governor of Virginia from 1808 to 1811, and Mary Armistead Tyler. John Tyler Jr., as he was often called, served in the Virginia House of Delegates, was governor from 1825 to 1827, and represented the state in both houses of the United States Congress. Elected vice president of the United States in 1840, in April of the following year Tyler became the first vice president to succeed to the presidency when William Henry Harrison died. Tyler retired in 1845 after completing one term as president, but in 1861 he was drawn back into service as chair of a national peace convention that met in Washington, D.C., in a failed attempt to avert civil war. Elected to the Virginia Convention in February 1861, Tyler voted for secession. He was elected to the Provisional Confederate Congress for the term that ended in January 1862, and to the House of Representatives of the First Confederate Congress, but before he could take his seat John Tyler died in his room at the Exchange Hotel in Richmond on Saturday, 18 January 1862.[3]

The bust is signed and dated 1862, but the circumstances under which it was created are unknown. For a week before his death Tyler received occasional visitors, but it is unlikely that that the ailing statesman then had the strength to sit for Volck. After Tyler's death on Saturday, the body lay in state at the Capitol from Sunday afternoon until the funeral on Tuesday. It is probable that Volck took a death mask from Tyler's body during that time and created the bust from it. The face has a hollow

appearance, as if gravity were acting on it, causing a backward sag of the loose skin and musculature, suggesting that the subject was lying on his back when a likeness or mask was taken. The ears are pinned back, as if pressed inward by the weight of plaster. It would not be unusual for a man of Tyler's advanced age to look drawn, but prior to his brief fatal illness Tyler was reported to be fit. There are no other known copies or versions of this bust, and there is no contemporary account of its creation, but the date confirms that it is certainly the last likeness taken of John Tyler, either shortly before or soon after his death.[4]

The provenance of Volck's bust of John Tyler is unknown. It does not appear in the Library's 1906 list of art but is included in the 1913 list.[5]

<div align="center">

TLK

</div>

NOTES

1. United States Census, City of Baltimore, Maryland, 1860, 11th Ward, National Archives and Records Administration, Washington, D.C.; Henry H. Wiegand, "American Work of Frederick Volck, Sculptor," Baltimore, Md., 1932, typescript, The Library of Virginia, Richmond; "Jackson's Statue from Death Mask," *Richmond News Leader*, 17 September 1937; C. C. March, ed., *Official Records of the Union and Confederate Navies in the War of the Rebellion* (Washington, D.C.: Government Printing Office, 1921), ser. 2, vol. 2, pp. 252–253.

2. Wiegand, "American Work of Frederick Volck, Sculptor"; Artist Research Files, Valentine Richmond History Center; "Volck's Bust of Lee," *Washington Post*, 13 June 1901, p. 4.

3. William G. Shade, "Tyler, John," *American National Biography* (New York and Oxford, Eng.: Oxford University Press, 1999), 22:77–79.

4. Oliver Perry Chitwood, *John Tyler, Champion of the Old South*, 2d ed. (Newtown, Conn.: American Political

Biography Press, 1996), 464–465; Robert Seager II, *And Tyler Too: A Biography of John and Julia Gardiner Tyler* (New York: McGraw-Hill Book Company, Inc., 1963), 469–472.

5. Earl G. Swem, *A List of the Portraits and Pieces of Statuary in the Virginia State Library, with Biographical Notes* (Richmond: Davis Bottom, Superintendent of Public Printing, 1913), 42.

REFERENCES

Chitwood, Oliver Perry. *John Tyler: Champion of the Old South*, 2d ed. (Newtown, Conn.: American Political Biography Press, 1996).

Seager, Robert, II. *And Tyler Too: A Biography of John and Julia Gardiner Tyler*. New York: McGraw-Hill Book Company, Inc., 1963.

Shade, William G. "Tyler, John." *American National Biography*, 22:77–79. New York and Oxford, Eng.: Oxford University Press, 1999.

"Volck, Frederick A." Artist Research Files. Valentine Richmond History Center.

Wiegand, Henry H. "American Work of Frederick Volck, Sculptor." Baltimore, Md., 1932, typescript, The Library of Virginia, Richmond.

INDEX

A CAPITAL COLLECTION: VIRGINIA'S ARTISTIC INHERITANCE

Designed by Amy C. Winegardner, graphic designer at the Library of Virginia. Page layout was produced by Winegardner using a Macintosh G5 and QuarkXPress 6.1. Text was composed in Janson and Trajan.

Printed on acid-free Ultra Litho Gloss 80-lb. text by Sheridan Books, Ann Arbor, Michigan.

Photography by Pierre Courtois, senior staff photographer at the Library of Virginia, using a large-format Sinar camera with a PowerPhase digital back and a Nikon digital SLR. Digital files were processed on a Macintosh G5 with PowerPhase, Nikon Capture, and Photoshop software.